THE MUMMY'S FOOT and THE BIG TOE

The Mummy's Foot
and the Big Toe

Feet and Imaginative Promise

ALAN KRELL

REAKTION BOOKS

To Sheila Christofides

Published by
REAKTION BOOKS LTD
Unit 32, Waterside
44–48 Wharf Road
London N1 7UX, UK

www.reaktionbooks.co.uk

First published 2018
Copyright © Alan Krell 2018

Printed and bound in China

A catalogue record for this book is available from the British Library
ISBN 978 1 78023 915 6

CONTENTS

Introduction

An anatomical configuration present in many vertebrates, the foot supports weight and makes ambulation possible. Both anchor and facilitator, it comes in countless configurations, from the webbed feet of many species of frog – delicate and diaphanous – to the complex structure of the human foot with its five toes, arch, heel and ankle. Echoing this number of toes are the (supposedly) five types of human foot: 'Egyptian', 'Celtic', 'Greek', 'Roman' and 'Germanic' – the last, for instance, characterized by a protruding big toe, while the 'Egyptian' is seemingly the most pleasing on the eye – a clean diagonal line from the big toe to the outermost and usually the smallest toe, known variously as the baby toe, the little toe or the pinky toe. These 'classical' typologies and charmingly prosaic descriptions hint at the foot's imaginative promise – the nub of this book.

In pursuing this imaginary, the foot's pedestrian role – in both senses of the term – gives way to a foot that refuses to tread carefully, one that puts its 'best foot forward' but may also 'step in the wrong direction'. With 'both feet on the ground', it may, by contrast, 'sweep you off your feet'. The ways in which the foot is constructed through text and image, both as a physical presence and as a

repository of ever-changing meanings, is where this book begins and ends. Located respectively in the contexts of literature, art, sport and film – the subjects addressed in this book – the foot is seen variously as fetish and fancy, object of desire and of abjection, and vehicle for the comic, the absurd and the empowering.

Chapter One focuses on the nineteenth-century French writer and art critic Théophile Gautier (1811–1872), and his 'The Mummy's Foot' (also the title of this first chapter). One of his *contes fantastique* (fantastic tales), this short story is little known except to those students and readers familiar with nineteenth-century French literature. It is used to introduce this book, however, because of its singular removal of the foot from its ordinary roles, allowing it to enter into the tantalizingly imaginary, where the foot becomes the subject of fantasy and fetish which charms and surprises through its anthropomorphic iterations and its indebtedness to Orientalism – a Western fascination with the Oriental 'Other'.

Chapter Two, 'The Big Toe and the Strange Feet', looks at another French writer and critic, Georges Bataille (1897–1962), together with the Australian artist Pat Brassington (b. 1942). 'Abjection' links them both; a notion embracing the 'unseemly', 'the unsaid', that would go on to become a much-discussed topic in postmodernist debates in the 1980s and beyond. Bataille's essay 'The Big Toe' was published in the Surrealist journal *Documents* in 1929, where it was complemented by black-and-white photographs of big toes by Jacques-André Boiffard. Picking up on Gautier's preoccupation with the illusory and the obsessive and relocating these in a confrontational discourse that traverses representation, both written and visual, 'The Big Toe' allows the

foot to walk, figuratively, on unconventional ground. And it is on equally disturbing ground that the work of Pat Brassington also 'walks'. One of Australia's foremost photo-based artists, she is influenced strongly by Bataille; her images reference Surrealism, Freud, feminism and fetishism.

The ground covered in Chapter Three, 'The Sacred, the Dirty and the Shocking', embraces, on the one hand, paintings in the western European canon that concentrate on the worshipped and the worshipper – from the washing of Christ's feet, to the Saviour himself washing the feet of the disciples, to the dirty feet of working-class believers. On the other hand, the chapter looks at the obnoxious yet equally 'sacred' practice of foot-binding that was once common in China. All these representations of these intimate acts – the washing of feet and the binding of feet – are caught up in questions of sexuality, gender and class.

Chapter Four, 'Baring Your Sole', focuses on professional running, on race and specifically on the experiences of the South African-born British runner Zola Budd (b. 1966) and the Ethiopian runner Abebe Bikila (1932–1973). Turning attention to an undervalued subject, barefoot racing – contested and considered especially African in Anglo-European circles, in which the passion for the 'barefoot' is both a practical and an ideological imperative – this chapter shows how the foot moves from its essential but prosaic roles into circumstances that elevate it to the status of 'stardom'. And this is achieved through the coming together of sport, ethnicity and politics.

Another type of 'stardom' surfaces in the final chapter, 'The Filmic Foot', in which the foot is able to take on an (imagined) life variously

as object of desire, of jest, of despair and even as instrument or harbinger of death. From directors Charlie Chaplin in the 1930s to Quentin Tarantino today, the examples discussed allow the foot to maintain its self-referential functions and meanings while also revisiting and subverting them. Bringing together the themes of this book in ways that both entertain and provoke, film gives the eccentricity of my subject – the foot and its imaginative promise – a wide traction.

The Mummy's Foot

Taking Théophile Gautier's quirky short story written in 1840 to introduce this book is, to repeat, a way of inviting the reader to rethink, hugely, the foot and its conventional meanings. At a time when he was 29 years of age, and had already achieved notoriety with his novel *Mademoiselle de Maupin* (1834), a cunning mix of irony and melodrama which targeted Romantic sentimentality, Gautier's 'The Mummy's Foot' ('Le Pied de momie'), continued in this tradition but moved emphatically into a genre known as *contes fantastique* (fantastic tales).[1] In its artful mix of the real and the imagined, Gautier's *conte* locates the foot in a never-never land where fact, fantasy and fetish co-mingle. It's a terrain where the foot is imagined as playful and impudent, caustic and charming – and promising much (illus. 1).

Local and imported influences all played their part in shaping 'The Mummy's Foot', but it is finally indebted, at least in terms of its narrative, to Orientalism, specifically Egyptomania, which emerged in France shortly after the Revolution of 1789 and was fuelled by Napoleon's Egyptian campaign of 1798–1801.[2] Despite a number of military victories, this attempt to extend France's imperialistic ambitions ended in failure; yet the establishment of

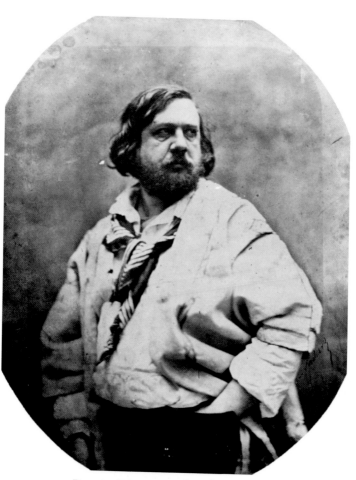

1 Portrait of Théophile Gautier by Nadar, *c.* 1857.

the Institut d'Égypte in 1798 in Cairo would see the founding of libraries and laboratories whose aim was to spread so-called Enlightenment values. At any rate, for Gautier and literary friends such as Charles Baudelaire, Barbey d'Aurevilly and Arsène Houssaye, the Orient functioned as 'that *elsewhere* where they could find beauty and escape from the ugliness of their society'.[3] This Orient or, more precisely, an imagining of it, would have an impact on a later generation of artists and writers, yet in the milieu that Gautier inhabited it took on very specific, topical meanings, none more so than in the fascination with the un-wrapping of mummies (illus. 2). As Claire Lyu has pointed out, through their importation mainly from Egypt and then being publicly shown in museums and at *expositions universelles* (universal exhibitions), mummies became 'the object of visual spectacle and the subject of literary fiction in the nineteenth century'.[4] This is seen not only in Gautier's 'The Mummy's Foot' and *Le Roman de la momie* (The Romance of a Mummy; 1858), but in other works from his so-called Egyptian series, 'Une Nuit de Cléopâtre' (One of Cleopatra's Nights; 1838) and 'La Mille et deuxième nuit' (The Thousand and Second Night; 1842). Significantly, all these texts were, as Lyu and others have observed, conceived before Gautier himself had 'set foot' in Egypt and before he had seen an actual unwrapping of a mummy – which he would not experience until the Universal Exhibition of 1867 in Paris.[5] Yet it is precisely Gautier's removal, as it were, from the actualities of the Orient that would allow him the distance he needed to move easily and evocatively through the imaginary space created by his writings.

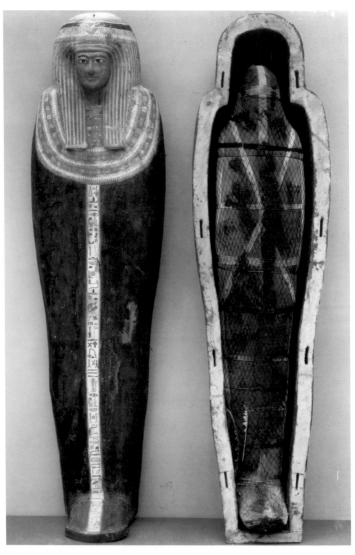

2 Mummy of Nesiamun, Egypt, *c.* 712–525 BC.

The narrator of 'The Mummy's Foot' – a *flâneur* – enters the shop of a *marchand de bric-à-brac* (bric-a-brac dealer) in an 'idle mood'.[6] Immediately striking a note of modernity, he talks about the proliferation of such shops where it has become 'fashionable to buy antiquated furniture [because] every petty stockbroker thinks he must have his *chambre au moyen age* [medieval room]'.[7] This evocation is quickly countered by the mention of dust, a dust that is the 'most manifestly ancient thing' and predates everything else on sale in the shop – items such as a Boulle cabinet (André-Charles Boulle, 1642–1732, one of France's leading cabinet makers) and 'enamelled works by Bernard Palissy' (a celebrated French ceramicist, *c.* 1510–*c.* 1590), but also 'Chinese silks and waves of tinsel', and 'immense Japanese dishes'.[8] (Facts always underpin the literary fantastic; out-of-this-world is always premised on the 'in-world', as it were.)

Though tempted by the dealer to purchase various artefacts, the narrator ultimately declines. He only wants, he says, 'a small figure – something which will suit me as a paper-weight . . .' Suddenly, his eyes fall on 'a charming foot' which he at first takes 'for a fragment of some antique Venus'. Immediately attracted to it, he declares: 'That foot will be my choice'. It is more than (simple) attraction, however. It is intensely sensual and physical:

> I was surprised at its lightness. It was not a foot of metal, but in sooth a foot of flesh, an embalmed foot, a mummy's foot. On examining it still more closely the very grain of the skin, and the almost imperceptible lines impressed upon it by the texture of the bandages, became perceptible. The toes were

slender and delicate, and terminated by perfectly formed nails, pure and transparent as agates. The great toe, slightly separated from the rest, afforded a happy contrast, in the antique style, to the position of the other toes, and lent it an aerial lightness – the grace of a bird's foot. The sole, scarcely streaked by a few almost imperceptible cross lines, afforded evidence that it had never touched the bare ground, and had only come in contact with the finest matting of Nile rushes and the softest carpets of panther skin.[9]

It soon becomes clear that Gautier's mummy's foot is none other than that of a certain Princess Hermonthis, the daughter of a pharaoh. The narrator and merchant quibble over its price, and an amount is agreed upon, soon after which the shopkeeper cautions the buyer: 'Old Pharoah will not be well pleased. He loved his daughter . . .'[10] His displeasure, of course, is to do with the intended use of the foot as a paperweight. (This shift from the living to the dead, the animate to the inanimate which soon will become animated once again, is one of the themes of the story.) Leaving the shop in a good mood, the narrator goes home and places the foot on his desk, 'upon a heap of papers scribbled over with verses'.[11] He then dines out with friends. Returning home, he is surprised by the smells of Oriental perfume, 'at once sweet and penetrating . . .'[12] With dreams of Egypt in mind, he goes to sleep. It's a disturbed and disturbing sleep. As Gautier tells it, fact and fantasy, actuality and reverie, move in and out of the narrator's mind. Where one ends and the other begins is never entirely made clear.

Assailed by odours and soon thereafter by a headache, the narrator's eyes happen to fall upon the desk where he had placed the foot of the princess.[13] From this point on, everything becomes possible. It is as if the narrator's gaze unlocks Pandora's box. Miraculously, the foot begins to move in exaggerated ways, leaping here and there, and causing the narrator to observe sardonically how 'very unnatural that feet should walk about without legs', and he commences to 'experience a feeling closely akin to fear'.[14]

This 'fear' soon gives way to amazement, however, when the narrator, who is now lying in his bed, sees the bed-curtains open to reveal 'a young girl of a very deep coffee-brown complexion . . . and possessing the purest Egyptian type of perfect beauty' (we soon learn that she is none other than the Princess Hermonthis).[15] Mesmerized by her presence, the narrator recalls the warning of the bric-a-brac dealer: 'Old Pharaoh will not be well pleased.' This, however, does not prevent him from noticing that the 'apparition had but one foot; the other was broken off at the ankle!'[16] Moving towards the table where the fidgeting foot is 'fidgeting more than ever', the now-tearful apparition – the girl, that is – tries to grasp the foot but is unsuccessful. What then ensues is a bizarre dialogue, worthy of a Surrealist conceit, between the princess and her own foot, one in which she confers affective attributes on it and all the while declares her affection and care for 'my dear little foot'. Here the object-transformed-back-to-a-living-foot becomes the object of desire for the host, as it were, who has suffered the original ignominy of the mutilation. To put it another way, the subject (Princess Hermonthis) is presented both as (passive) victim and (active) lover of her own

foot (if this latter conceit may be imagined), as suggested in this quote below:

> Well, my dear little foot . . . I always took good care of you. I bathed you with perfumed water . . . I smoothed your heel with pumice-stone mixed with palm oil . . . you supported one of the lightest bodies that a lazy foot could sustain.[17]

Responding, the foot takes the princess to task for disregarding the violation of her (the princess's) tomb by an 'Arab' acting on behalf of the bric-a-brac dealer; 'it is I,' the foot says, who sanctioned the theft. (Gautier's reference to tomb theft, incidentally, was a remarkable observation for its time). The foot then asks, 'Have you five pieces of gold for my ransom?'[18]

From this point on, the narrative moves in and out of even more preposterous but equally fascinating scenarios. These involve the princess retrieving her foot, 'which surrendered itself willingly this time', and adjusting it to her leg in the most clear-headed of ways.[19] This action invokes thoughts of her father, whom she speculates would be well pleased that her 'mutilation' has been redressed. Before going any further, however, she removes from her neck a little idol-figure made of green paste and offers it to the narrator as a substitute for the paperweight. (Freud's fascination with the foot and castration/mutilation are echoed here: the father happy in the knowledge that his daughter's 'mutilation' has been resolved; and then the fetish itself – the embalmed foot, which of course morphs into the Princess Hermonthis herself, becomes something lost and something gained.) This idol-figure, which resurfaces later

in the narrative, is in fact an image of Isis, the Egyptian goddess of women and fertility, who was believed to possess magical powers. Contrary to her usual attributes, and there are many, including a modified cross, a sun disc and a rattle, Gautier's Isis carries 'a whip with seven lashes'.[20] Apparently, the Egyptian cult of Isis 'honoured the Gods by whipping girls in the temples', although why exactly these lashings were required is uncertain.[21] This cameo appearance of an elaborate whip, however, fits easily into the psycho-sexual nature of 'The Mummy's Foot'.

After presenting the narrator with the figurine, the princess invites him to meet her father, an invitation the narrator thinks is perfectly reasonable. Passing through various fantastic architectural structures, they arrive in a vast hall where the princess finally introduces the narrator to her father, the Pharaoh. Exclaiming in delight 'I have found my foot again!', the princess informs her father that 'it was this gentleman who restored it to me'.[22] Taken aback but clearly thrilled, the Pharaoh asks the narrator what he wishes as recompense (after all, he had lost his paperweight). 'Your daughter in marriage,' he responds. Alas, this is declined: we are told that the Pharaoh considered his age – only 27 years – infinitely too young for the princess, whose longevity, the father says, is cast in stone. 'The Mummy's Foot' concludes with the narrator being awakened suddenly by a friend. Dressing himself hurriedly, he looks for some document on his desk, only to discover 'the little green paste idol left in its place by the Princess Hermonthis!'[23]

As befits the genre, Gautier's *conte fantastique* moves effortlessly from the improbable to the plausible, the incredible to the credible.[24] And underpinning the narrative is always its sense of

comic adventure and irony.[25] It is Gautier's ability to conjure up an absurdity couched in a possibility and negotiated through play and irony that, it seems to me, is the defining feature of 'The Mummy's Foot'. But it is the foot of course that allows Gautier to construct his remarkable narrative: it is 'both a physical object and the focus of the reader's interpretative strategies reading the text.' There is no substantial part of the story to which the 'foot does not relate'.[26] Variously an appendage, a desirable object, a 'victim' of dismemberment, a comic player and a loved and missed limb, the foot, dead and mummified to begin with, and then wildly animated, allows Gautier to touch on such diverse questions as Orientalism, memory, seduction, fetishism, necrophilia and immortality.

Presented with the foot of a dead and mummified woman, an Egyptian princess no less, readers are taken from this generalized Orientalist interest in mummification to something far more local-ized: 'In several of the more remarkable prose works by Théophile Gautier', Sima Godfrey has pointed out, 'fashionable young men [an appropriate description of the urbane dandy who is the nar-rator in 'The Mummy's Foot'] fall madly in love with dead women, a number of whom are Egyptian and embalmed.'[27] Such is the woman in 'The Mummy's Foot', whose mummified foot was the object that first besotted the narrator. When later this 'fragment' takes on a life of its own – when it confronts the narrator with its own vital presence – the animated appendage forces the narrator to re-think his earlier exaggerated description of its sensual attrac-tion, and he now adopts a far more studied response: 'I became rather discontented with my acquisition, inasmuch as I wished

my paperweights to be of a sedentary disposition . . . '[28] Drollness aside, this observation suggests his reluctance, soon turning into fear, when the foot turns into a flesh-and-blood person, an exquisitely beautiful young woman. Anything that smacks of a real engagement, it would seem, is anathema: after all, he had simply purchased something; it was an 'acquisition', as he describes it – nothing more and nothing less.

At first reading, the classic ingredients for a conventional Freudian understanding of 'The Mummy's Foot' are there in droves: fetish, dismemberment and loss. For Freud, the fetish is that which has been (irretrievably) lost for the male infant; he recognizes that his mother does not have a penis and *assumes* that it has been castrated (a big big leap, but there you are). It is the fetish, Freud argues, that will serve as protection against this fear of castration and its consequences.[29]

But while Gautier's story clearly focuses on 'a female foot, a classic Freudian fetish object', the narrative also invites, as Jutta Emma Fortin argues, a Marxian understanding of the commodity-fetish.[30] Here she quotes from the section in *Capital* in which Marx writes about the 'Fetishism of Commodities'. In part, the cited passage – an important one – reads:

A commodity appears, at first sight, a very trivial thing, and easily understood. Its analysis shows that it is, in reality, a very queer thing, abounding in metaphysical subtleties and technological niceties . . . It is . . . clear . . . that man by his industry, changes the forms of the materials furnished by nature, in such a way as to make them useful to him. The

form of wood, for instance, is altered, by making a table out of it . . . But, so soon *as it steps forth* as a commodity, it is changed into something transcendent. It not only *stands with its feet on the ground*, but in relation to other commodities, it stands on its head, and evolves out of its wooden brain grotesque ideas, far more wonderful than 'table-turning' ever was.[31]

It is a happy coincidence that Marx turns to the idiomatic use of the word 'foot' to anchor his views since, as we have seen, this seemingly innocent use of the 'foot' kicks into a long history of the word and its multifaceted meanings. Marx's singular understanding of the commodity-fetish, however, impinges directly on a reading of 'The Mummy's Foot'. This understanding sees the commodity taking on a life of its own – a 'mysterious' character, one that establishes a 'fantastic' relationship with humans. The jump from this theorizing to the nuts and bolts of Gautier's *conte* is small – becoming animated, the embalmed foot literally takes on a life of its own, thereby entering into an extraordinary relationship with the narrator, one begun, as we have seen, with the narrator's strong, sensual attraction to the object (with its 'slender and delicate' toes) which he first takes 'for a fragment of some antique Venus'. Once the haggling over how much to pay the dealer is completed – once the deal, the consummation of the 'commodity fetish', has been completed – the 'object' is taken to the narrator's home, and it is there, in this new domestic context, that it begins moving hither and thither and then, in another miraculous feat, changes into a 'real' woman who radiates exquisite charm and allure. That the

foot redeems itself – put another way, finds its 'true' embodiment in the form of the Princess Hermonthis, her earlier, lost self, in the comforting delights of the narrator's home – sets up the domestic interior as the antithesis to the milieu of the bric-a-brac dealer which is one of crass commerciality in which the fetish of the commodity prevails.

'The Mummy's Foot' is a tour de force of style and content. Its conceits move effortlessly from the actual to the possible and finally – and surely – to the impossible. Making the foot, literally, part of the exotic Other – the mummy – Gautier takes death, renewal and reverie as the themes surrounding his re-energizing of this most commonplace of 'things'. Inviting us to rethink (almost unwittingly) the foot's normative function, Gautier presents a wonderfully engaging space cunningly rich with the possibly impossible.

DOCUMENTS

ARCHÉOLOGIE
BEAUX-ARTS
ETHNOGRAPHIE
VARIÉTÉS

6

Magazine illustré
paraissant dix fois par an

Carl EINSTEIN. Tableaux récents de Georges Braque. — Georges BATAILLE.
Le gros orteil. — D' Henri MARTIN. L'art solutréen dans la vallée du Roc
(Charente). — Dessins inédits d'Ingres. — Marcel GRIAULE. Totémisme
abyssin. — Le trésor de Nagy-Szent-Miklosz. — Alejo CARPENTIER. La
musique cubaine.

Chronique par Jean Babelon, Jacques Baron, Georges Bataille, A. Eichhorn,
Carl Einstein, Marcel Griaule, Michel Leiris.

Photographies de Jacques-André Boiffard et Eli Lotar.

PARIS, 106, B^d Saint-Germain (VI^e)

3 Cover for *Documents* No. 6 (1929), the Surrealist journal in which
Georges Bataille's 'The Big Toe' was published.

The Big Toe and the Strange Feet

George Bataille's essay 'The Big Toe', unlike Gautier's mischievous and ironic treatment of the foot, is dark and disturbing but strangely seductive, in ways similar to the work of Pat Brassington, whose images of feet mix the bizarre and the beautiful in unsettling ways.

Born in 1897 in Billom, in the Auvergne region of France, Georges Albert Maurice Victor Bataille (known simply as Georges Bataille) was a French intellectual who worked across a wide range of disciplines including literature, anthropology, philosophy, sociology and the history of art. His writings, described cogently by the Bataille scholar Benjamin Noys as 'thought without mastery' (a wonderful conundrum worthy of Bataille) continue to influence scholars dealing with notions of 'base materialism', 'abjection' and 'sovereignty' – the latter, a critical term in Bataille's thinking, understood by him to be destabilization verging on negation in which the 'normal' is subverted.[1] That said, everything about Bataille is to do with subversion in one form or the other.

Mercurial and idiosyncratic, Bataille was a lifelong friend of literary and artistic luminaries such as Michel Leiris (writer, ethnographer and Surrealist) and André Masson (also a Surrealist).

He was de facto editor of the irreverent and threatening Surrealist journal, the Paris-based *Documents* (1929–30); anti-fascist and articulator of new and disturbing concepts which urged a re-thinking of the divisions between 'high' and 'low' culture, 'good' and 'bad', the 'respectable' and the 'unacceptable'. He died in Paris on 8 July 1962.

Bataille's 'The Big Toe' ('Le Gros orteil') was published in *Documents* No. 6 (1929), with black-and-white illustrations by the photographer Jacques-André Boiffard (1902–1961), who was associated with the Surrealist Bureau of Research in the mid-1920s and from 1929 onwards, was close to Bataille and other (dissident Surrealist) writers attached to *Documents* (illus. 3). In 'The Big Toe', Bataille formulates an understanding of this appendage in ways that would go on to grab the imagination of countless scholars and commentators (I use 'grab' rather than 'capture' here since it is more in keeping with Bataille's passion for the adulterated). That said, however, the presence of Boiffard's photographs in this essay certainly helps explain its mightily affective nature, in which text and image come together in ways that Freud (and Bataille himself) would understand to be the 'uncanny', a concept in which something can be both familiar yet strange at the same time, resulting in feelings of disquiet and anxiety.

Although *Documents* set out to be an (eccentric) scientific review, it very soon became the focus for what Olivier Chow has described as 'the provocative, disturbing and frankly monstrous [, quickly becoming] a war machine against surrealism'.[2] This is not the place to elaborate on the differences between *Documents* and orthodox Surrealism, embodied in its founder, André Breton

(1896–1966). Suffice it to say that *Documents* unequivocally foregrounded that which was always nascent in Surrealism – the so-called gruesome, the vile, the grotesque – and presented it in ways that were framed within disinterested and 'documentary' perspectives.

So what to make of 'The Big Toe'? Finding my way to the relevant text in *Encyclopaedia Acephalica* (1995), an indispensable source on Bataille and his writings, I chance upon the word 'spittle' in his 'Critical Dictionary', a regular segment in *Documents*:[3]

> SPITTLE. *Spittle-Soul.* –
> One can be hit full in the face by a truncheon or an automatic pistol without incurring any dishonour; one can similarly be disfigured by a bowl of vitriol. But one can't accept spittle without shame . . . For spittle is more than a product of a gland. It must possess a magical nature because, if it bestows ignominy, it is also a miracle-maker. Christ's saliva opened the eyes of the blind . . . In Occidental Africa, to confer spirit on the child, the grandfather spits into the mouth of his grandchild several days after his birth.[4]

This short extract captures the essence of Bataille's provocations: transgressive ideas presented in language that both infiltrates and subverts readers' expectations and understandings.

'The Big Toe' is a short essay, some 1,700 words. Its startling beginning has Bataille declaring that 'the big toe is the most *human* part of the human body', and he goes on to explain why:

no other element of this body is so differentiated from the corresponding element of the anthropoid ape (chimpanzee, gorilla, orang-utan, or gibbon). This is due to the fact that the ape is tree-dwelling, whereas man moves over the ground without clinging to branches, having become a tree himself, in other words he has raised himself erect in the air like a tree ... [5]

Just when readers might think that Bataille's understanding of human 'erection' – this is the term he uses – is the essence of a humanity that raises its 'head to the heavens', they are quickly disabused of this notion:

Although within the body blood flows in equal quantities from high to low and from low to high, there is a preference in favour of that which elevates itself, and human life is *erroneously* [my emphasis] seen as an elevation ... Human life requires, in fact, this rage of seeing oneself as a back and forth movement from ordure [a French term meaning solid waste released from the body], and from ideal to ordure, a rage that is easily directed against an organ as *base* as the foot.[6]

Here Bataille begins to flesh out one of his fundamental ideas: humans see themselves as removed – positively so – from all that constitutes 'ordure'. Not only is this mistaken, he will argue elsewhere, suggesting that 'base materialism' (his term) is essential to their make-up, but this form of materialism can itself be subversive. Any attempt to differentiate between mind and body

is therefore futile.[7] To put it another way, elevating matter into spirit is a falsehood. So what determines life, Bataille in effect proposes, is death; and death is simply 'evidence of matter overwhelming life'.[8] But to return to 'The Big Toe', Bataille goes on to say that the human foot is 'subjected to grotesque tortures that deform it', being

> stupidly consecrated to corns, calluses, and bunions, and if one takes into account turns of phrase that are only now disappearing, to the most loathsome filthiness: the peasant expression 'her hands are as dirty as feet', is no longer as true of the entire human collectivity as it was in the seventeenth century.[9]

Halfway through 'The Big Toe', Bataille turns from feet in general to the 'gros orteil' in particular, which he introduces (almost) tongue-in-cheek by way of the 'Man' who is attracted to the 'grandeurs of human history', but then is brought down to earth, as it were, 'by an atrocious pain in his big toe'. Not, as one might have supposed by gout, that acute inflammatory infection of the big toe – represented here in an extraordinary etching by James Gillray, 1799, showing gout personified as a devilish creature (illus. 4) – but by corns.[10] Insofar as a corn is a particular shaped callus of dead skin, this association with mortality would surely have appealed to Bataille. Corns allow him to spend an inflamed paragraph on their 'baseness' and on how they differ from other bodily pains such as 'headaches and toothaches'; toes, he postulates, are nearly always 'more or less tainted and humiliating.'[11]

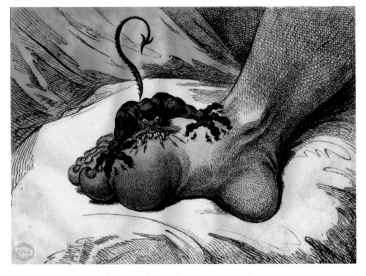

4 James Gillray, *The Gout*, 1799, etching.

The big toe, Bataille continues, is not inherently 'monstrous', unlike, he suggests, a gaping mouth. For Bataille, the big toe acquires its 'ignominy' through what he says are 'secondary (but common) deformations' which confer on the big toe 'an exceptionally ludicrous nature'.[12] Thus it is that he is able to segue ingeniously into 'seduction', which he considers to be at its most extreme an insight into the ludicrous. He writes,

if one considers, for example, the case of the Count of Villamediana, one can affirm that the pleasure he had from touching the queen's foot was in direct proportion to the ugliness and infection represented by the baseness of the foot, in practice by the most deformed feet. Thus, supposing that the queen's foot was perfectly pretty, his pleasure would

still have derived its sacrilegious charm from deformed and muddy feet.[13]

While this description sounds apocryphal, the good Count did in fact exist (1582–1622), a poet who by all accounts had widely divergent sexual proclivities. The queen to whom Bataille refers was in all likelihood Margaret of Austria, the wife of Phillip III of Spain.

Bataille's parting shot on the big toe has him opining on 'classic foot fetishism': 'leading to the licking of toes [this exercise] categorically indicates that it is a base form of seduction, which accounts for the ludicrous value that is more or less always attached to the pleasures condemned by the pure and the superficial.'[14] Perhaps Lady Chatterley was thinking along similar lines when she famously described her first sexual encounter with the gamekeeper as this 'ridiculous bouncing of the buttocks.'[15]

THE PHOTOGRAPHS

Accompanying Bataille's essay in *Documents* No. 6 were three black-and-white photographs by Boiffard of the 'Big Toe'.[16] Often, however, only one is reproduced in the literature – for example, *Big Toe, Masculine Subject, 30 Years Old*, which to me is the one that most resembles a big thumb (illus. 5). This conceit appeals, since it raises the important question of the relationship between hands and feet, between *Homo erectus* and 'man' with his feet in Bataille's metaphorical sludge, between a lofty reading of the human, and one that is rooted in the abject.

5 Jacques-André Boiffard, *Big Toe, Masculine Subject, 30 Years Old*, 1929.

6 Jacques-André Boiffard, *Big Toe, Masculine Subject, 30 Years Old*, 1929.

Boiffard differentiates along gender lines, two of his photographs being described as 'masculine', and the third as 'feminine'. Seemingly simple in their imaginings, each toe fills the entire black space of the picture; all are dramatically cropped and framed vertically. There is one instance in which the appendage is shown with what appears to be part of the flesh that connects it to the rest of the foot. This is a jarring image (illus. 6). The photographer/ viewer must be looking down at the toe, but there is simply no way to account rationally for this 'additional' piece of flesh – at the angle at which we see it, the big toe must either have been manually pulled away, as it were, from the remainder of the foot or Boiffard has intentionally manipulated the photograph to create an affect that, for want of a better word, is 'dislocated'. Surely this is the case, and it also applies to the other two photographs.

I've been speaking about perspective, literally. We look down at the big toe in illus. 6, while in illus. 5 the toe seems to move out of its black space and slightly towards the viewer's right; more than the other two, the toe here seems to hover in a void. *Big Toe, Feminine Subject, 24 Years Old* (illus. 7) is perhaps the most uncanny of all three, the toe coming in from the right of the image: disturbingly extended and contorted, it takes on the character of a slug with the toenail as its 'head'. Olivier Chow has written perceptively on Boiffard's cropping and angles:

> The photographs are cropped, the angle imposes a violent deformation of the toe – they are upside down, brought down if such an operation were possible. It is a portrait that transgresses and subverts the very idea of what a portrait

7 Jacques-André Boiffard, *Big Toe, Feminine Subject, 24 Years Old*, 1929.

should be: the highest and most noble part of the body has been thrown away and transformed into a grotesque, absurd and scandalous 'other face'.[17]

I return to illus. 6: that the owner of this toe is male invites considerations of the penis/phallus, which this image certainly suggests. In the same manner, the ambiguous perspective allows a reading that has the toe pointing down (rather than being seen from above), a perspective that makes it redolent of a scrotum; the smattering of hairs just above the toe-line further enhances this. Enticingly, the American scholars David E. Garland and Tremper Longman III, specialists in the New Testament, note that in Isaiah 7:20, the 'hair of the feet' is synonymous with pubic hair, while

in Ezekiel 16:25, to 'spread the feet is to present the vagina for intercourse.'[18]

The nails in all three of Boiffard's toes are anything but healthy-looking. Cracked, scarred and blemished, they complement Bataille's textual references to the deformed, diseased and distressed. Then there are the other touches: a few bits of hair in illus. 6 – strangely alien (but, as mentioned above, a suggestion perhaps of pubic hair) – and the creases in the skin which give to this image of the big toe a reptilian quality; and the gradations of grey/black in illus. 5, culminating in a nail that with its harsh black outlines and blurred 'face' brings to mind a television screen emptied of 'content'. Returning finally to illus. 6, if one can visualize cutting off the big toe just at the point that the sprigs of hair appear, then what we end up with is an image that startlingly resembles part of a chest, armpit and arm – the body as a whole is thus incriminated, something of which Bataille would approve.

PAT BRASSINGTON

Born in Hobart, Tasmania, in 1942, Pat Brassington has said:

> Years ago, I read Freud's *Totem and Taboo* ... If I think about it, it must have been a catalyst for me in some ways. It was Freud's musings on 'the unconscious' and the 'return of the repressed' that fuelled my desire to probe into some aspects of surrealist practice. The fascination is still with me. It's not that I want to travel down the same road, but it is a lantern in the window.[19]

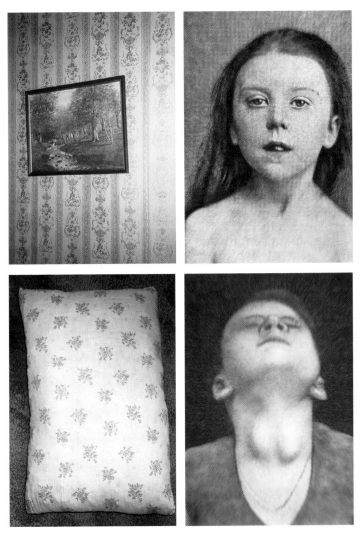

8 Pat Brassington, *In My Mother's House*, 1994, four silver gelatin prints.

Freud's *Totem and Taboo* was an early anthology of four essays published in 1913. Often left out is its subtitle, *Resemblances Between the Mental Lives of Savages and Neurotics*.[20] This omission is understandable since here Freud draws freely on the racist stereotyping of his day. That said, his essays, especially the first called 'The Horror of Incest', would no doubt have appealed to Brassington: here Freud focuses on the role of totemism in the lives of Australia's first peoples to make out a case against incest.

In 2005, Brassington held two exhibitions, 'You're So Vain', at Stills Gallery in Sydney, and the other, some months later, at Arc One Gallery, Melbourne, titled 'In the Same Vein'. In both, Brassington presented works that included disturbingly beguiling images of feet wrapped, decorated, deformed, dissolved and relocated. The play on the words 'vein' and 'vain', as one critic rightly said at the time, was typical of the artist's preoccupation with the 'humorous and visceral'.[21] To place these images in context, however, let's look at an earlier work by Brassington from a series of four photographs titled *In My Mother's House* from 1994 (illus. 8).

An extraordinary conceit, these images look back cunningly to the Surrealist Man Ray's photograph of his lover, American photographer Lee Miller (1907–1977), showing her neck and chin pulled sharply backwards so that, in Man Ray's hands, they evoke the stylized image of a phallus (illus. 9). With Brassington, the allusion to male genitalia and sexual content is explicit: the Adam's apple appears, in effect, as two testicles (might they not also suggest two small breasts?) protruding from the flesh of the neck. As to the ears, these come across as fleshy protrusions recalling nothing less than the open mouths of little vipers.

Greys, diluted pinks, drained sepias and occasional drops of red dominate the work Brassington showed at Arc One Gallery in Melbourne. In *Like a Bird Now* (illus. 10), we look down at the Mannerist-like 'stretching' of the feet of a woman. Set against a mottled backdrop, the feet disown, as it were, their 'owner'. Protruding in from the upper margin of the photograph is a shape that resembles a snake's head. This adds a sexual allure, to be sure, but in the end it is the feet that are the focus of the gaze, especially the two toes on each foot which take on a much lighter colour than the remainder of the digits. One might be forgiven for thinking that we are looking at flesh that has broken through nylon stockings. Unsettling seduction is the game here.

9 Pat Brassington,
In My Mother's House,
1994, detail.

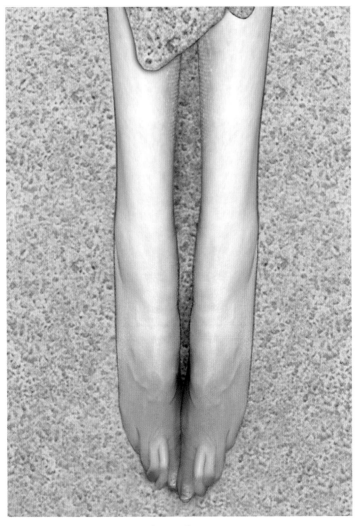

10 Pat Brassington, *Like a Bird Now*, 2010, pigment print.

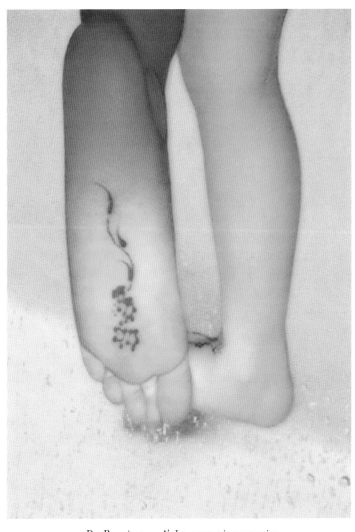

11 Pat Brassington, *A's Joy*, 2005, pigment print.

Brassington's *A's Joy*, meanwhile, has a sole, unusually pink, reaching from the top almost to the bottom margin of the photograph; it stares us in the face (illus. 11). The calligraphic tattoo (what else can it be?) is sharp red. Pink is everywhere in Brassington's work.

'What is it with pink?' the freelance cultural critic Ashley Crawford asks rhetorically: 'Traditionally it's meant to be feminine, but with Brassington's palette it is cloying, a kind of entrapment.' To this, Brassington responds, 'Your interpretation feels fine . . . Pinkness can be skin deep, the veil drawn over blood red capillaries.'[22] Elsewhere in this article, Brassington is more emphatic: 'It's not my intention to feminise the image by using pink . . . It's nastier than that. Pink smothers.'[23]

The ashen right leg in *A's Joy* seems unusually small; cut off at about the point of the knee, the foot, partially seen tucked behind the other, is a forlorn-looking thing. (What, by the way, are we to make of the messy brown blemish that appears at the angle where this foot meets the leg?) Standing in or on what appears to be salt or very small ice particles, a further contextual ambiguity, the (central) foot in *A's Joy* invites comparison with what have now become commonplace on the web – images of celebrities' feet seen up close and personal. Take this recent photograph of the American fashion designer and actress Nicole Richie in Saint Barthélemy (6 April 2013), a chic island in the Caribbean Sea (illus. 12). Seen from behind, in a bikini and kneeling as if she were about to jump off from the starter's block, her soles stare us in the face. Or take this snap (illus. 13) of the outlandish Kim Kardashian, TV and media personality, holidaying in Miami (11 June 2010): her body

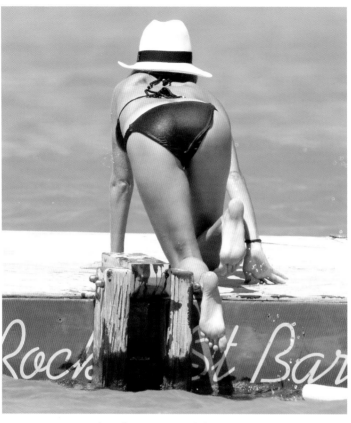

12 Nicole Richie in Saint Barthélemy, 6 April 2013.

dramatically foreshortened, she lolls on a sunbed, sunglasses raised and cell phone in her hand.

Not only is the female foot/sole prized by the paparazzi, but so too is the male's, such as this photograph (illus. 14) of the English comedian, radio host and activist Russell Brand, seen leaving his yoga class in Los Angeles – but here, and in other instances in which men are photographed, it seems to me that the naked foot

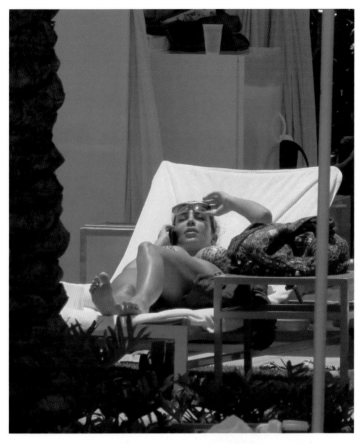

13 Kim Kardashian in Miami, 11 June 2010.

often is simply part of the figure's affectations rather than an object of desire.

Nothing could be further removed from the 'celebrity foot' than Brassington's *Until* (illus. 15), a photograph that, it seems to me, alludes to the pointed toes of a ballerina – about to, or already, pirouetting. Here, however, the feet are turned into a bizarre visual

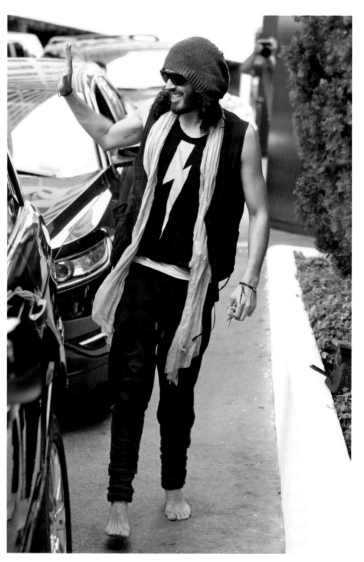

14 Russell Brand in Los Angeles, September 2013.

play, quasi-Surrealist in conception, that is an amalgam of wrist, waist, torso and legs. As Ashley Crawford observes in a lengthy and close analysis of Brassington's oeuvre,

> The theatrical, dance and cinema seep through [her] work. At least one image recalls the harrowing figure prominent in the Japanese horror film *Ring*. But not surprisingly, it is the savage, visceral Martin Scorsese film, *Raging Bull* with its balletic and bloody boxing scenes that is one of Brassington's favourite films.[24]

This mix of the beautiful and the bloody invites consideration of the phenomenon of Oscar Pistorius (b. 1986), the famous South African sprinter whose legs were amputated below the knees in early childhood. Running with artificial limbs, he became known as the 'Blade Runner'. In 2014 he was found guilty of culpable homicide for the murder of his girlfriend, Reeva Steenkamp. On 3 December 2015, however, a South African appeals court revoked the sentence and pronounced him guilty of murder. In the proceedings prior to judge Thokozile Masipa's ruling on the (original) sentence, the chief defence lawyer, Barry Roux, asked Pistorius to remove his prostheses and walk a few steps to demonstrate his vulnerability at the time of the killing. One of the photographs taken at this time is reproduced here (illus. 16). It is a mightily pathetic image that I find redolent of Brassington's *Until* and its seemingly loose limbs in limbo. And this and other works by Brassington will always resonate when placed alongside images of the disabled, such as Marc Quinn's sculpture of the artist Alison Lapper, *Alison Lapper*

15 Pat Brassington, *Until*, 2005, pigment print.

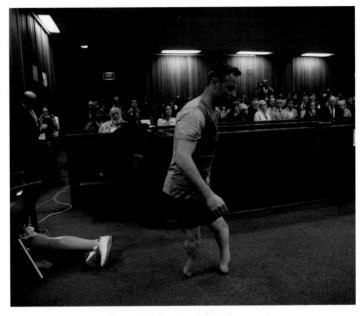

16 Oscar Pistorius in court, 15 June 2016.

Pregnant, which occupied the fourth plinth in London's Trafalgar Square between September 2005 and late 2007. Here we saw her seated, her stylized face looking determinedly to its left, pregnant, armless and legs truncated.

Bataille's essay, Boiffard's photographs and Brassington's photo-media images variously address the foot and its imaginary dimensions. Yet linking all of them is abjection: that which is considered beyond the pale – the (so-called) base and the despoiled. Bataille's manifesto on the big toe – and that, in effect, is what it is – introduces us to a part of the body that he sees as maligned, nasty and ludicrous. Boiffard's accompanying photographs show the big toe, blemished and pathetic, isolated in the black and blank

space of the photograph. Brassington, meanwhile, moves from these darkened spaces to a (literally) bright-lit scenario of pinkish limbs in which the foot, though, is still imagined as out of the ordinary, equivocal and troubling.

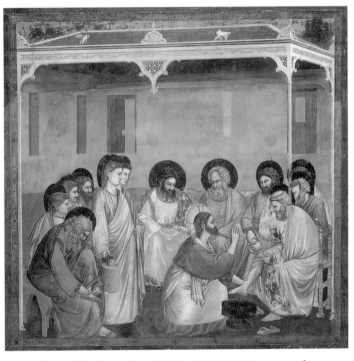

17 Giotto di Bondone, *Christ Washing the Disciples' Feet*, c. 1305, fresco.

The Sacred, the Dirty and the Shocking

Let a little water be brought, and then you may all wash your feet and rest under this tree. (GENESIS 18:4)

'I regret binding my feet,' Zhou says. 'I can't dance, I can't move properly. I regret it a lot. But at the time, if you didn't bind your feet, no one would marry you.'[1]

Looking at the ways the foot is esteemed and demeaned, this chapter takes its cue from the imaginary – in this instance, the world of painting – and contrasts it with the actualities of daily life, which leaves little to the imagination. It places Christianity's preoccupation with the foot, especially the washing of the feet of Christ – a theme ubiquitous in western European art – alongside the practice, now banned for many years, of the binding of female feet in China.

WASHING AND ANOINTING THE FEET

Jesus's washing and drying of the feet of the disciples (John 13:1–17) took place shortly before the Last Supper. Commentary on

this event makes the following points, time and again: it was an act of humility, of unadulterated love and, most importantly, of 'servant leadership', a notion that goes back thousands of years to, say, Chanakya, the legendary Indian professor who, in the fourth century BCE, wrote in his book *Arthashastra*, an ancient Indian treatise on statesmanship and military strategy, that

> the king [leader] shall consider as good, not what pleases himself but what pleases his subjects [followers]. The king is a paid servant and enjoys the resources of the state together

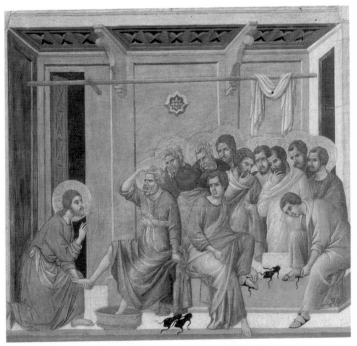

18 Duccio di Buoninsegna, *Christ Washing the Disciples' Feet*, 1308–11, tempera on panel.

with the people. Previously it sounded like the 'importation' became the spectacle.[2]

Yet Jesus's action goes well beyond 'servant leadership'. It is seen as the act of someone who willingly performs a subservient task; to be precise, Jesus takes on the role of a servant in a household who has the responsibility of washing the feet of his 'master'. Most travel at this time was by foot with or without sandals; feet were dirty and probably stank. To wash them, to remove the patina of the roads, was considered a lowly task, one to be undertaken, to repeat, by servants. Certainly, the washing of feet was always associated with questions of class.[3]

In the hands of Duccio (*c.* 1255–1318), Jesus (illus. 18) is shown holding the right foot of Peter (also known as Simon Peter) with his left hand. Peter will say to Him, 'Lord, are you going to wash my feet?' to which Jesus will reply, 'You do not realize now what I am doing, but later you will understand.' 'No,' replies Peter, 'you shall never wash my feet.'[4] An incredulous Peter simply cannot grasp that Christ will undertake such a demeaning task. Little is given away in the poker-faced expressions of Christ or Peter in Duccio's painting, but the disciple does scratch his head in a bemused way while the others look variously confused and contemplative. Perhaps the most startling motif in the image is the three deep-black-coloured sandals, two removed from Peter and one from the disciple on his immediate left, that acquire qualities of living things (tadpoles?) that slither, disturbingly, in a diagonal left to right beginning from the bottom of the painting and almost at exactly its middle point. The animation of these three shapes,

verging on the creepy, turns Christ's gesture into a troubled and troubling activity.

Meanwhile, Giotto (*c.* 1267–1337), a contemporary of Duccio, uses similar pictorial conventions in his depiction of the same subject, but makes important changes (illus. 17). The Saviour moves from an isolated figure on the left (in the Duccio), to one immersed – as it were – in the gathering of disciples, one of whom – bearded and on the far left – seems far more concerned with his own foot/sandal than the seriousness of what is taking place before him. Unlike the Duccio, in which Christ holds the foot of Peter in an awkward manner, here He grabs Peter not by his foot, but some inches above it on his lower leg.

A delicate play between foot and limb, between touching and holding, and between looking and not looking characterizes the serene and formally austere Duccio. By contrast, the long, narrow canvas of the Venetian Tintoretto (1518–1594), one of at least six he did on this subject, is all drama, plunging diagonals, distant vistas and theatrical action (illus. 19). The deep perspective of the table takes our eye across the decorative floor to the columns, colonnade, boat on the lake and, finally, to an archway in the distance, but this neat progression is interrupted by some stunning vignettes: the placid dog just off foreground centre, looking just past Christ who is shown on (our) far right (more about him later); the man (without halo), on the extreme left, head down and concentrating on tying the straps of his sandal; and Tintoretto's pièce de résistance, I think, the two figures to the left of the table, one (with halo) on his knees, who is trying his best to pull off what I can only understand to be some sort of (leather?) leggings from the

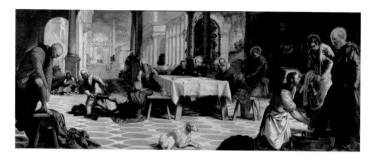

19 Jacopo Tintoretto, *Christ Washing the Disciples' Feet*, c. 1575–80, oil on canvas.

grey-haired man dressed in blue, who tries to anchor himself by leaning on the bench to his right.

The rubbing of the commonplace with the extraordinary – a Breughel-like insistence on how a dramatic death such as that of Icarus falling from the sky, can go unnoticed by people going about their daily activities – is a major theme in Tintoretto's painting. Yet it is precisely this dominance of the quotidian in Tintoretto's interpretation that turns Christ's action into such a poignant incident. Illuminated and, as I have said, way off to our right of the picture, he is a muscular man wearing a white apron. Kneeling, he seems to invite Peter (perhaps there is even a hint of insistence) to put his foot/feet into the wooden tub. An obsequious-looking servant with bowed head holds the ewer containing water. Christ's feet are in deep shadow and not visible; it is as if the immensity of such a seemingly innocent task – washing Peter's feet – cannot be adequately represented.

Not so for the English artist Ford Madox Brown (1821–1893). Working variously with medieval, religious and contemporary subjects, Madox Brown's interpretation of Christ's washing of the feet

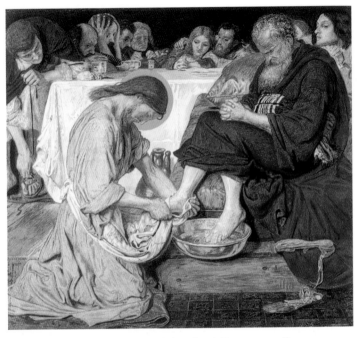

20 Ford Madox Brown, *Jesus Washing Peter's Feet*, 1852–6, oil on canvas.

of Peter (illus. 20) has the Saviour kneeling and looking intently at the disciple's right foot, which He grasps firmly in one hand and cushions with the other. A small brass (?) bowl of water replaces the large tub in the Tintoretto; as in that work, however, there is a figure on the left who is untying his sandal, but here he leans on a table and appears to be looking out of the corner of his eyes at Christ. To his immediate left, there is a group of four figures, one of which, stricken-looking, grasps his head in hands. Peter, meanwhile, is a huge presence who, with clasped hands, gazes intently at his right foot being gripped by Christ, his sandals appearing almost accidentally in the bottom right of the picture.

Compared to the three other paintings we have looked at – those by Duccio, Giotto and Tintoretto – Madox Brown's is the most visceral, showing a determined Christ, 'hair wet with sweat' and head down, focused on the strenuous task of washing Peter's feet. In like manner, the apostle's entire being is focused on the activity. These two figures fill the almost-square canvas, lending to it the effect of immediacy and intimacy. In another context, it might be that Peter is simply having a vigorous foot massage! What we see illustrated here, it must be pointed out, is Ford Madox Brown's revised version of his earlier painting on the same subject (Christ washing St Peter's feet), which, when it was first exhibited at the Royal academy in 1852, showed a semi-clad Jesus. A critic in *The Art Journal* wrote of the original painting,

> we have here a nude figure of the Saviour washing the feet of Peter. We care not whether the exhibitor affect pre- or post-Raffaellism, but we contend that coarseness and indignity in painting are always objectionable. It is most probable that the feet of Peter were not those of Apollo, but it is also probable, if severe truth be insisted upon, that they were proportionable [sic] to the figure. It is not the office of Art to present us with truths of an offensive kind; these are abundant in every-day life, and it is in Art that we seek refuge from them.[5]

This reviewer's understanding of Madox Brown's painting as a compromising of an Art that should be dedicated to the beautiful

and the noble is one that we will come across again when discussing the work of Caravaggio and Manet.

Just now, though, it is Mary Magdalene's anointing of Jesus's feet that needs to be considered, for if Jesus washing the feet of the disciples is all about love and humility, then Mary's act is far more layered – one that brings into question her multiple, at times conflicting, roles borne witness to by historical and contemporary accounts.

Present at Jesus's Crucifixion and Resurrection, Mary Magdalene has been seen variously as saint, harlot, repentant sinner and clandestine lover of Christ. Her anointing of Jesus is one of the few events reported by each of the four Gospels, although the details of their stories differ. Some note the anger expressed over the expensive perfume 'nard', an amber-coloured oil also called 'spikenard', that Mary used to smooth over Jesus: the disciples 'were indignant', we read in Matthew, asking, 'Why this waste?', while John has it that the obdurate (my description) Judas was especially upset because he felt that the money received for the sale of the perfume could have enhanced his coffers.[6] As regards Mary's use of her long hair to dry Jesus's feet, this is only recorded by John and (probably) Luke.[7] So, in summary, the various readings of Mary Magdalene construct her as a will-o'-the-wisp character, part good and part bad, interested and disinterested, saint and sinner.

That she was a repentant prostitute, the single most important censure levelled at her, is now largely dismissed by biblical scholars, although it continues to get oxygen in popular culture – Andrew Lloyd Webber's pop opera *Jesus Christ Superstar* (1970), for example; Martin Scorsese's film adaptation of Nikos

Kazantzakis's novel *The Last Temptation of Christ* (1988); and Mel Gibson's *The Passion of the Christ* (2008). Of course, in the Judaeo-Christian tradition there is a patriarchal vein, sexist in more ways than one, that finds in a bad woman turned good a winning story of Godly redemption.

The 'original' source for a woman anointing the Saviour's feet is found in Luke 7:36–50, in which she is not identified by name, but is described as a 'sinner'.[8] In the other three Gospels of the New Testament – Matthew, Mark and John – Mary Magdalene is neither mentioned as Christ's wife nor as a prostitute, but simply as 'a witness of his crucifixion and/or his burial'.[9]

Stories within stories, attributions and contradictions constitute the narrative of Mary Magdalene, but here I simply draw attention to Luke and its relevant passage, since it is this that in all likelihood would have provided the literary backdrop to the works of the artists I discuss. It must be quoted at length:

36 Now one of the Pharisees invited Jesus to have dinner with him, so he went into the Pharisee's house and reclined at the table.

37 When a woman who had lived a sinful life in that town learned that Jesus was eating at the Pharisee's house, she brought an alabaster jar of perfume,

38 and as she stood behind him at his feet weeping, she began to wet his feet with her tears. Then she wiped them with her hair, kissed them and poured perfume on them.

39 When the Pharisee who had invited him saw this, he said to himself, 'If this man were a prophet, he would know who is touching him and what kind of woman she is – that she is a sinner.'

40 Jesus answered him, 'Simon, I have something to tell you.' 'Tell me, teacher,' he said.

41 'Two men owed money to a certain moneylender. One owed him five hundred denarii, and the other fifty.

42 Neither of them had the money to pay him back, so he canceled the debts of both. Now which of them will love him more?'

43 Simon replied, 'I suppose the one who had the bigger debt canceled.' 'You have judged correctly,' Jesus said.

44 Then he turned toward the woman and said to Simon, 'Do you see this woman? I came into your house. You did not give me any water for my feet, but she wet my feet with her tears and wiped them with her hair.

45 You did not give me a kiss, but this woman, from the time I entered, has not stopped kissing my feet.

46 You did not put oil on my head, but she has poured perfume on my feet.

47 Therefore, I tell you, her many sins have been forgiven – for she loved much. But he who has been forgiven little loves little.'

48 Then Jesus said to her, 'Your sins are forgiven.'

49 The other guests began to say among themselves, 'Who is this man who even forgives sins?'

50 Jesus said to the woman, 'Your faith has saved you; go in peace.'[10]

The little-known Artus Wolffort (also Wolffordt and Wolffaert) was born in Antwerp in 1581. An artist who favoured history painting, landscapes and portraits, and whose work was influenced by his contemporary Rubens (seen especially in Wolffort's representations of women with fleshy cheeks and puckered lips, a 'type' much favoured by Rubens), Wolffort's *Mary Magdalene Washing the Feet of Christ* shows Mary in a richly brocaded, golden-yellow and salmon-pink dress, foreground centre, kneeling dramatically with eyes closed and embracing Christ's left foot (illus. 21). In the cramped space of this painting, Mary, in her voluminous gown, controls the action by default, since she, among all the other personages, is the most inert. But many eyes focus on her, her cascading hair and the revealed flesh of arm and neck: Christ in a disinterested way; the apostle leaning on the table with glass in hand who stares steadfastly at Mary's action; similarly, the elderly man to his left who raises a hand to his spectacles to help better

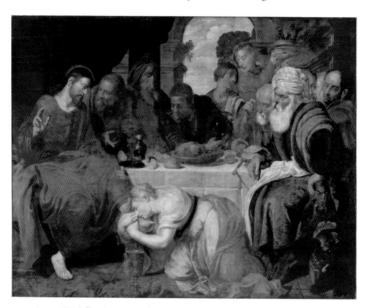

21 Artus Wolffort (1581–1641), *Mary Magdalene Washing the Feet of Christ*, oil on panel.

focus on the scene; finally, the resplendent apostle on our far right who looks in Mary's direction but whose gaze passes above her head at something out of the picture's frame. The ointment container is there, placed prominently in the foreground, but Wolffort has chosen not to depict any of Luke's claims: there is no washing of Christ's feet with tears, no kissing of them, no anointing of them with oil and no drying of the feet with Mary's hair. A generous observation would be that the painting is about male fascination with an event that seems beyond their comprehension. A less generous one would have it that Wolffort's personages are the equivalent of the two Elders looking vicariously on at Susannah (Daniel: 13): old men fascinated by a younger woman, as shown in

22 Pierre Subleyras, *The Meal at the House of Simon*, 1737, oil on canvas.

paintings by a raft of artists including Rembrandt and Rubens and the less widely known Guido Reni (1575–1642) and Alessandro Allori (1535–1607).[11]

By contrast, Pierre Subleyras' *The Meal at the House of Simon* (1737), a long, narrow canvas seen today in the Musée du Louvre (illus. 22), seems at first to draw on various accounts of Mary's engagement with Jesus taken from Matthew 26:6–13, Mark 14:3–11, Luke 7:36–50 and John 11:55–57; 12:1–11. Born in Saint-Gilles-du-Gard in 1699, Subleyras studied in Rome and died there in 1749. A little-known but intriguing artist whose paintings of intimate encounters in eighteenth-century French Libertine politics need far more investigation, Subleyras, in this huge picture (122 × 50.5 cm), presents a tableau vivant of gestures, actions and dispositions from huddled assemblies of men and occasional women; moments of intense activity and a looking here and there; and off to our right and nearly breaking into the viewer's space, a long-limbed dog grasping at a joint of meat. To the far left, Jesus is all insouciance: leaning back on a table, his right hand points upwards, while his left foot with toes clearly delineated is shown languorously dangling. Mary, like her counterpart in the Wolffort, is kneeling, her naked right shoulder revealed and highlighted, but, unlike

the former – in what is an equally subordinate role – she allows her long hair to enfold Christ's foot to dry it, as described in the Book of Luke, but also to caress it in a nearly sexual manner, hence alluding back to her supposed status as a 'sinner'. Here I draw a long bow: looking at the painting – and I have spent hours in the Louvre doing just that – I cannot help but 'see' and make connections between Mary and the dog whose shared bodily movements – both 'kneeling', as it were – are to the viewer's right, countering much of the picture's compositional thrust in the opposite direction. In the animal's eating away at the meat, an unambiguous act of carnality, there might also be a parallel with Mary's alleged 'loose morals'.

Nothing could be further removed from Subleyras' vast tableau, frenetic but frozen, than *Mary Magdalene Washing Christ's Feet* by William Blake (1757–1827). English painter, poet and printmaker Blake's small pen-and-ink and watercolour, only some 30-square-cm, was commissioned and purchased by Thomas Butts, a passionate champion and financial supporter of Blake (illus. 23). A restrained image made up of creams, browns and greys, it shows eight figures assembled around a table located in a stark architectural setting. Christ is on our right. Seen lounging in profile, he pays no attention whatsoever to Mary, who touches his right foot with her right hand and ever so gently kisses it. If the Saviour appears at the very least without interest, then the apostles are equally so, one looking upwards, others looking here, there and everywhere, but never directly at Christ nor at Mary.

The same cannot be said of Jean Béraud's *St Mary Magdalene in the House of Simon the Pharisee*, shown in the Paris Salon of 1891

(illus. 24). Noted for his paintings of *la vie parisienne* (the Parisian life) in Belle Époque Paris, Béraud (1849–1935) here parts company with this genre to imagine, albeit within the parameters of a 'Realist' practice, an otherworldly religious event. Take the ten figures closest to Christ's right, seemingly individual portraits of well-heeled men: Béraud shows some bearded, some clean-shaven, one or two bespectacled, some talking among themselves, others lost in contemplation, but all looking intently at the Saviour who

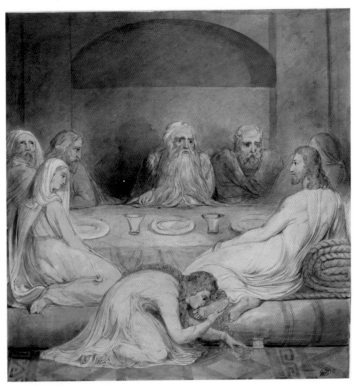

23 William Blake, *Mary Magdalene Washing Christ's Feet*, c. 1805, pen, ink and watercolour over graphite on paper.

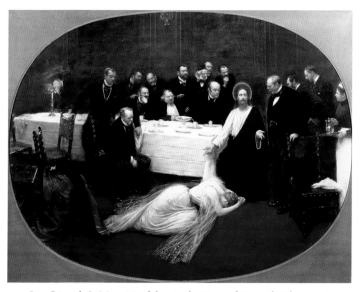

24 Jean Béraud, *St Mary Magdalene in the House of Simon the Pharisee*, 1891, oil on canvas.

comes across as this rather nonplussed 'modern' figure, gobsmacked by what is happening before him. And this of course is Mary's melodramatic falling at his feet, fully dressed but with a diaphanous veil cocooning her, head down and hands grasped in a pleading way that brings to mind the representation of the 'fallen woman' (an epithet for a prostitute in Victorian England) in Augustus Egg's 'triptych' called *Past and Present* shown at the Royal Academy in 1858: the central canvas depicts a distraught wife – allegedly an adulteress – who has thrown herself prostrate in front of her husband; her hands are wildly outstretched and clenched. While Béraud's Mary is similarly shown as (literally) a 'fallen woman', thus an explicit link with the Book of Luke and its assumptions, she is not depicted realizing any of her (supposed)

roles. Certainly there is no foot washing or drying or anointing; indeed, the foot is noticeable by its absence. (Béraud's 'modern' realization of a religious subject is filled with the contradictions that we will encounter in Manet's two paintings of Christ, discussed below. With Béraud, however, there is no suggestion whatsoever of the wit or irony characteristic of Manet.

Writing in *The Art Journal* in 1891, Claude Phillip had this to say about Béraud's painting:

Sacred or pseudo-sacred Art appears here [the Salon in the Champ de Mars] in its most eccentric forms. First comes what has to the badauds ['lookers-on' or 'bystanders'] been the sensation of the Champs de Mars Exhibition, the 'Magdalen at the Feet of Christ' of M. Jean Béraud. This skillful and not usually very emotional delineator of modern Parisian scenes, has this time chosen to outdo Herr Fritz von Uhde [a German painter of genre and religious subjects, who died in 1911] on his own ground, but has done so with a cold deliberation which makes his work wilfully offensive, while that of his Saxon prototype is both tender and reverential in spirit. Here, in a modern Parisian room, crowded with male notabilities in fashionable morning dress, one of whom lights a cigarette at a table loaded with the remains of a sumptuous *déjeuner*, is placed the figure of Christ, draped in the usual flowing garments, *while at his feet has cast herself in a prostrate attitude a beautiful demi-mondaine*, robed in the last creation of [Charles Frederick] Worth or [Jacques] Doucet [renowned English and French fashion designers

respectively]. The portraits are here so admirably done, and the figure of the Saviour, on the other hand, so feeble and ineffectual, that the average spectator is at first less strongly repelled than might have been expected.[12]

Or take these pithy comments from the English *Daily News* correspondent: 'M. Béraud's picture came in for a good deal of adverse remarks. It was to Christianity, said some, what Offenbach's opera bouffé was to the Olympus of Homer.'[13]

DIRTY FEET, REALIST OUTRAGES

We now turn to Édouard Manet (1832–1883), painter of *la vie moderne* (modern life), whose only real forays into religious painting were the works he exhibited respectively in the annual Salons of 1864 and 1865: *The Dead Christ with Angels* and *Jesus Mocked by the Soldiers* – disconcerting images in which feet (the feet of Christ) are central to the works' affects.[14]

The Dead Christ with Angels (illus. 26) first registers as a straight-forward painting. But this initial understanding soon becomes one of puzzlement. The two angels are remarkable entities. One seemingly wipes something from her eye, while the other closest to the Saviour gazes out of the picture and to our left. Totally self-absorbed, her expression complements that of Christ, who is shown eyes partly open but inward looking, seeing but not seeing, alert but inert.[15] Adding further to the oddness of the painting are the angels' voluminous folds of drapery and resplendent wings that seem in effect to be fixed to flesh-and-blood models. Wrote the

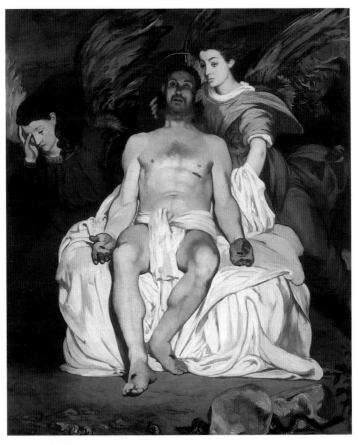

25 Édouard Manet, *The Dead Christ with Angels*, 1864, oil on canvas.

novelist and art critic Théophile Gautier at the time of the paint-ing's first showing, 'The angels, one of whom has brilliant azure wings, have nothing celestial about them, and the artist hasn't tried to raise them above a vulgar level.'[16]

While there are other peculiarities in the painting, it is to Christ's feet that I turn. The puncture marks from the nails that

held Him to the Cross are clearly visible, as they are on his hands – the 'traditional' fifth perforation, the lance wound in Christ's chest is seen just under his left nipple. The feet are painted in an extraordinarily summary way, unique in Manet's oeuvre. The left one is barely hinted at (a mangled piece of flesh that echoes the darkened, mitt-like left hand of Christ), while the right foot has this strange blur close to the big toe (a feature first pointed out by Michael Fried), a painted smudge, nothing more, nothing less, typical it seems to me of those other conceits Manet often introduced into his work.

Unlike *The Dead Christ with Angels*, in *Jesus Mocked by the Soldiers* we are of course looking not at a corpse but a sentient human (illus. 26). Three 'soldiers' dressed in an odd mixture of contemporary and historical costume surround Christ, whose features border on the pathetic. His hands are tied at the wrists and hang limply to one side. The soldiers consist variously of a powerfully built, barefoot soldier, wearing a bandana around his head, who looks out at the viewer with eyes wide open and mouth agape. To his right, a bearded older figure with a stave, and sporting a peculiar helmet, stares with curiosity at Christ. Finally, the kneeling soldier dressed in what looks like pantomime attire holds a reed and gazes incredulously up at Christ. The moment Manet has depicted is that of Jesus's captors mocking the 'king of the Jews' by crowning Him with thorns and covering Him with a purple robe, although in Manet's picture the soldier holds the cloth more as a theatrical backdrop to Christ's body than anything else.

An overwhelming sense of incredulity surrounds Manet's personages. Christ is depicted as a rather clumsy, fleshy type, whose

predicament is a cause of bemusement to himself and to the others around Him. His large and ungainly feet, 'Realist' in their rendition, seem to me those we might associate with that rag bag of social types Karl Marx first described as the 'lumpenproletariat' in *The Eighteenth Brumaire of Louis Bonaparte*, written in late 1851 to early 1852, and originally published in the German monthly magazine *Die Revolution*. Written about the coup that allowed Louis-Napoléon Bonaparte to assume power in France, Marx in this polemic speaks about the

> offshoots of the bourgeoisie, [who] were vagabonds, discharged soldiers, discharged jailbirds, escaped galley slaves, swindlers, mountebanks, pickpockets, tricksters . . . brothel keepers . . . in short, the whole indefinite, disintegrated mass, thrown hither and thither . . . which the French call *la bohème*.[17]

Marx understood the 'lumpenproletariat' to be a working class that was beyond class-consciousness and hence of little or no use to the realization of a classless society.[18] I am not suggesting Manet subscribed to these (problematic) ideas, or that he was even aware of Marx's essay, although we know he was a staunch Republican and a fierce critic of Napoléon III. What I am suggesting is that the cast of characters featured in *Jesus Mocked by the Soldiers* could well have been drawn from Marx's constructed constituency. So it should come as no surprise that the caricaturist Bertall (pseudonym for Charles Albert d'Arnoux) nicknamed Manet's painting 'The Foot Baths', and depicted Jesus in exaggerated ways as a rag-and-bone

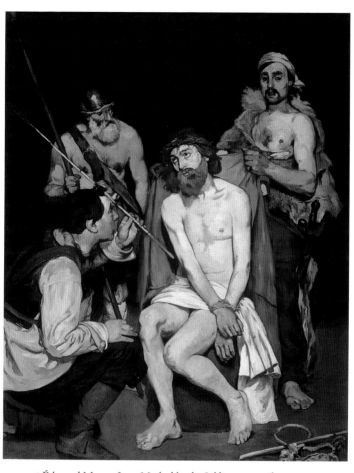

26 Édouard Manet, *Jesus Mocked by the Soldiers*, 1865, oil on canvas.

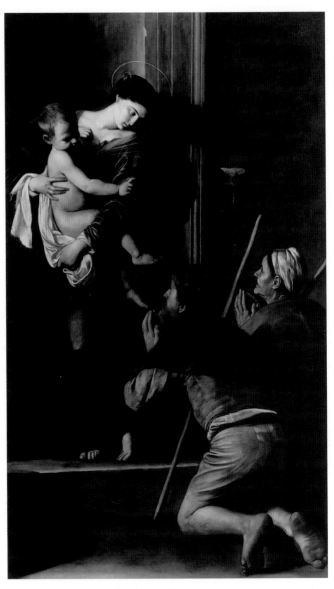

27 Caravaggio, *Madonna of Loreto*, 1604, oil on canvas.

man (one of Marx's 'lumpenproletariat') surrounded by 'four employees of the grand sewer collector'.[19] Here Bertall provocatively brings together the aesthetics of Realism with questions of filth, class, sewage and sanitation.

Similar constructions of 'filth' and 'class' orbit the Italian artist Caravaggio (1571–1610) and representations of feet in his religious paintings, in which the renowned nineteenth-century English art critic John Ruskin saw nothing but 'horror and ugliness, and filthiness of sin.'[20] Born in Milan in 1571, Michelangelo Merisi (or Amerighi) da Caravaggio's flamboyant character and equally colourful (but disputed) life – homosexuality, drunkenness, theft, murder – led to much legend-making in his day and subsequently. Take, for instance, Derek Jarman's biopic *Caravaggio* (1980), which portrays the artist as 'a rowdy homosexual who didn't just fraternize with criminals but actually was one, sentenced to death for murder after a duel', or the novel *M*, by Peter Robb (*c.* 1988) which similarly makes much of Caravaggio's sexuality and ornate life.[21]

The *Madonna of Loreto* altarpiece is to be found in the shallow chapel of the Cavaletti family in the church of Sant'Agiostino, Rome (illus. 27). Encapsulating, I'd suggest, the weightiest of Caravaggio's innovative but controversial practices in the early years of the seventeenth century, it is a tall, narrow canvas that shows two people worshipping at the feet of the Madonna and Child. Looking up at the head of the towering Madonna, the viewer shares a similar experience to that of the kneeling man and woman. The Madonna looks down on all of us. Unusually tall, she holds in her arms the Christ child, whose elongated body confirms Caravaggio's early allegiance to Mannerism. One of the Madonna's two feet

peers discreetly out from under her dress, five digits, nothing more, while the other, slender and fine, is on its toes, in an awkward pose. These two cryptic intrusions of paint-as-describer contrast with the soles of the male pilgrim, covered in dirt, and which seem to reach out at a diagonal from the bottom (our) right of the canvas into the spectator's space.

What to make of these dirty limbs? According to Giorgio Baglione in his book on the lives of painters, sculptors and architects in Rome, published in 1642, the work raised a commotion among ordinary people who (supposedly) took exception to the grubby feet and the old woman's shabby hat.[22] Another scholarly commentator, Francesco Scannelli, wrote,

> Whoever looks at this painting must confess that the spirit of the pilgrims is well rendered, and shows their firm faith as they pray to the image in the pure simplicity of their hearts. On the other hand, it is evident that the painting lacks proper decorum, grace and devotion . . . [23]

Scannelli is hedging his bets. There is more to the matter, however. Howard Hibbard, an authority on Italian art of the sixteenth and seventeenth centuries, would articulate the core of the problem in his book on Caravaggio published one year before his (Hibbard's) untimely death in 1984. His observations, it seems to me, still persuade. In summary, Hibbard says that the painting 'is based on a spatial diagonal, one that resolves on the dirty feet of a kneeling male pilgrim'; that Caravaggio presents in flesh and blood terms 'a particularly tangible apparition . . . a miracle happening

to simple, poor, contemporary people'; and that – and this is the crucial point,

> these people are pilgrims, on pilgrimage to a holy shrine of the Virgin . . . If the pilgrimage to Loreto was sometimes made barefoot, the infamous dirty feet of the painting . . . would even be *decorous in the iconographic sense*. Removing one's shoes in a holy place was an ancient custom, and the dirt emphasizes the pilgrims' humility (a word deriving from *humus*, soil).[24]

By problematizing the 'dirty feet of the painting', Hibbard allows this so-called 'irreverence' to be reassessed in a new light. But even more interestingly, Hibbard goes on to address the much-quoted observation of Baglione that has him saying – and here I quote Hibbard directly:

> The picture caused quite a stir. Baglione, disapproving, said that 'da popolani ne fu fatto estremo schiamazzo,' which can be translated as 'the common people made a great cackle over it.' Since he [Baglione] used the word *schiamazzo* on the same page to describe the propaganda that had led [Vincenzo] Giustiniani [an Italian banker and patron of Caravaggio] to overvalue Caravaggio's pictures, we may take the word to mean 'unjustified praise.' Thus Baglione may be reporting that the simple people who were portrayed in Caravaggio's picture *saw it and approved of it*. It must have been the talk of the town.[25]

The 'talk of the town' indeed! Pilgrims walking hither and thither, taking their shoes off, revealing dirty feet; all hastening to catch a glimpse of the Madonna and Child, and – miraculously – seeing their own selves, as it were, in that magical picture.

This brings us to *Madonna and Child with St Anne* (*Madonna dei Palafrenieri*) (illus. 28), a commission Caravaggio received for an altar of the papal grooms (*Palafrenieri*) in the new Basilica of St Peter. Installed there for only a few days, it was

> then removed to the nearby church of the Palafrenieri, Sant'Anna [and] by 16 June 1606 it had been sold to Cardinal Borghese for 100 *scudi*. By that time Caravaggio had left Rome for good.[26]

A large painting approximately 3 m high, *Madonna and Child with St Anne* depicts two women and a naked boy, all of whom gaze at an incident taking place, literally, beneath the left feet of the Madonna and the infant Christ. Both Mary and the boy step on the head of a writhing snake whose body captures silvery passages of light and whose calligraphic configuration suggests some cryptic meaning: what to make of the (almost) perfectly circle-like eye-glass that constitutes the tip of the serpent's tail? Meanwhile, St Anne, the mother of the Virgin, towers above the group: wrinkled face tilted down, mouth slightly open and hands clasped. In characteristic fashion, Caravaggio locates the dramatis personae very near the 'front' of the canvas and emerging, as it were, from an oily black space that is both background and ambience. Wearing a sharp red dress that displays her ample breasts (part of the garment

28 Caravaggio, *Madonna and Child with St Anne (Madonna dei Palafrenieri)*, 1605–6, oil on canvas.

hangs like a segment of a curtain, underlying the theatricality of the tableau), Mary holds the Christ child around his chest and under his left arm, all the while looking curiously yet with a degree of diffidence at what is happening under their feet.

Undertaken in the presence of Mary's mother, this stepping on the snake, often described as 'trampling' – which it certainly is not – suggests a concerted multigenerational triumph over Eve's 'fall' at the hands of the serpent, itself emblematic of 'original sin'.[27] Further, as Catherine Puglisi, a specialist in Italian Baroque art has suggested, the 'vanquished serpent' would have 'symbolized for Catholic viewers of the post-Reformation era the Church's victory over the most recent embodiment of Satan: Protestant heresy'.[28] Yet whatever the niceties of Counter Reformation dogma and their representation – real or imagined – may have suggested, the committee responsible for the rebuilding of St Peter's Basilica found *Madonna and Child with St Anne* unacceptable and had it removed.

These slippery associations of the snake – evil, sexuality, deceit, repression – move into speculative territory that invites a brief return to Caravaggio's 'feet' in *Madonna and Child with St Anne*. To repeat in different terms what I have already said, Mary's high-arched foot does not, as it were, step on the snake; it is her toes that make contact and then only gently. The infant Jesus, meanwhile, places his foot on Mary's, hesitantly, his left big toe placed just above his mother's. This is an act that strikes me as paralleling St Anne's right thumb positioned upon her left. (That a big toe and a thumb share visual similarities is surely clear: Boiffard's photographs of this digit in Bataille's 'The Big Toe' bear this out.) One further correspondence between St Anne and the Christ child suggests

itself: the forefinger of Mary's right hand echoes both the infant's penis and its angle. All this adds to the tantalizing, intimate links between Caravaggio's three protagonists – the mother (Blessed Virgin Mary), the child (Jesus) and the grandmother (St Anne).

TIED UP IN FOOT-BINDING

Caravaggio's feet tread here and there in ways that bring together religion and mythology, class and sexuality and nearly always in confrontational ways. Stepping from these themes to Chinese foot-binding may seem gratuitous. On the contrary: the binding of so-called 'Lotus feet' similarly insisted on gender and class, desire and devotion.[29]

Principally an activity of the upper class from the thirteenth until the seventeenth and eighteenth centuries, when daughters of peasantry began to emulate the practice, foot-binding was outlawed in 1911 by the new Republic of China after the fall of the Qing Dynasty. But its grip on the social imagination would persist – and this notwithstanding official censure by the Chinese Communist Party when it came to power in 1949. Subsequently, and in secret, foot-binding continued sporadically.[30]

Zhou Guizhen, aged 86 in 2007 when she was interviewed, living in Liuyicun, a village in southern China's Yunnan province, remembered these clandestine happenings with a mixture of nostalgia and remorse:

> When people came to inspect our feet, my mother bandaged
> my feet, then put big shoes on them . . . When the inspectors

came, we fooled them into thinking I had big feet . . . I regret binding my feet . . . I can't dance, I can't move properly. I regret it a lot. But at the time, if you didn't bind your feet, no one would marry you.[31]

Suggested in these simple words is the anxiety at the heart of foot-binding – the anxiety of physical pain, on the one hand,

29 The lotus feet of a 90-year-old woman in the village of Tuanchan, Yunnan, China, in 2008.

and the anxiety experienced by women having to conform to an intractable male gaze on the other. Foot-binding was a dreadful, painful process: the ideal length of the bound foot was approximately 8 cm (3 in.).[32] Often the practice led to the foot arch lifting so that the heel would more or less touch the metatarsals, the five long bones in the foot (illus. 29).

Fifty women who lived into very old age with their extreme deformities were traced and recently interviewed and documented over an eight-year period by Jo Farrell, a British photographer living in Hong Kong.[33] Her first subject was Zhan Yun Ying:

> It was kind of shocking but in some ways beautiful ... When she took her shoes and socks off, her feet were totally, fully in lotus shape. To me, they represented the trouble and toil this woman [has] been through – and what women do go through – to attract a partner ... There was something quite tremendous about it.[34]

Referring to the ninety-year-old Si Yin Hin, Farrell says,

> Yin's feet were the most distorted that I have ever seen. To me, they no longer looked like feet – they have taken the shape of the shoes. Her feet had never been unbound, and she managed to keep them hidden.[35]

From these demonstrative observations of an outsider Farrell moves on to those of an 'insider', Su Lian-qi, who stated that when she

first started binding it was very painful, so much so that I couldn't sleep at night . . . Many girls suffered more than I did. When I couldn't stand the pain any longer I would secretly loose the bindings; when my mother found out she wouldn't get angry or scold me. She had bound feet, too, and understood how much it hurt. She would let me keep the bindings loose for a while, but I always had to wrap them up tightly again. I would wash and rebind my feet every day – it had to be done that often because the binding cloth gets caked with blood and pus.[36]

Foot-binding was a nasty and foul practice. In its wretchedness, however, the foot acquired an alarmingly seductive character, both in its time and in later years, evinced, for example, in Farrell's easy transition, cited above, from 'shocking' to 'beautiful'.

What then are we to make of the term 'lotus feet' to describe foot-binding? And how do these two gentle words sit with a practice that is sexist, invasive and injurious? Let's dispense, first, with the (popular) view that the bound feet resemble the lotus. They do not. If anything – and by contrast – the tapered bound foot comes very close to the animal's cloven hoof. Purity, spiritual rebirth and beauty are overarching meanings of the lotus flower in Buddhism and Hinduism, but how exactly do these meanings sit in the specific context of foot-binding?

As Dorothy Ko has written, 'Chinese poets and storytellers would often fixate on parts of a maiden's body as a stand-in for the beauty or worth of her entire person.'[37] It is a Freudian fetish, though perhaps not in so many words. Wrote the third-century

poet Cao Zijian (192–232) of the Goddess of the River Luo, one
of the earliest of maidens,

> She is dimly described like the moon obscured by light
> clouds . . .
>> Examine her close up,
>> And she is dazzling as lotus emerging from limpid ripples
> . . .
>> She drapes herself in the shimmering glitter of a gossamer
> gown . . .
>> She treads in patterned Distant Roaming slippers . . . [38]

In these lines the lotus and the foot – the latter signified by 'Distant
Roaming slippers' – come together in sensual and suggestive ways.
A new genre seems to have emerged from this and other similar
poems. Take Han Wo (844–*c.* 923), a scholar whose occasional
poems included 'Ode to Slippers':

> Glowing, glowing, six inches of succulent flesh;
> Embroidered slipper in white silk, lined in red.
> Not much of a romantic, the southern dynasty emperor,
> Yet he prefers the golden lotus to green leaves. [39]

Haunting lines about sexual attraction that touch on the abject
(how else to understand 'six inches of succulent flesh'?), we are
here far removed from paintings of the washing of Christ's feet by
his disciples or by Mary Magdalene, and those paintings showing
(male) peasants with their grubby feet worshipping the Madonna

and Child. 'Ode to Slippers' relocates foot-binding in a rarefied world that flies in the face of the realities of this horrible practice and its effects on women, while the imaginings of Christ, his feet and their ablutions, construct another world of seemingly secure meanings.

Baring Your Sole

E vidence as to Man's Place in Nature is the imposing title of the first book devoted to the subject of human evolution. Published in 1863, only five years after Darwin's *Origin of Species*, and written by the English biologist and champion of Darwin's theory of evolution, Thomas Henry Huxley (1825–1895), it set out to demonstrate that humans and apes have common ancestry. To illustrate this thesis, Huxley turned to the now widely known set of five drawings of skeletons that show the 'progression' from gibbon through orang-utan, chimpanzee, gorilla and finally to man – and it *is* surely a man, since the representation of an upright and eyes-looking-forward skeleton could never have been conceived as a female at this juncture in history (illus. 30).[1] Used as a frontispiece in *Evidence as to Man's Place* to privilege the 'upright position', Huxley goes on to articulate a view of human evolution that, as Tim Ingold has written, posits 'a progressive differentiation between the hands as instruments of rational intelligence and feet as integral to the mechanics of bipedal locomotion.'[2] Not for nothing do the claw-like hands in the diagrams Huxley reproduces end up, in Man, as urbane, even welcoming – perhaps, as Ingold suggests, about to shake hands with someone we do not

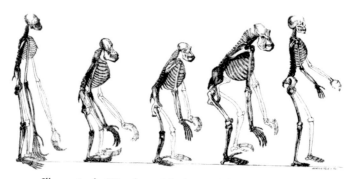

30 Illustration by Waterhouse Hawkings in Thomas Henry Huxley, *Evidence as to Man's Place in Nature* (1863).

see. Elsewhere in his absorbing article, Ingold quotes a telling observation of Huxley's:

> It must not be forgotten . . . that the civilized great toe, confined and cramped from childhood upwards, is seen to a great disadvantage, and that in uncivilized and barefooted people it retains a great amount of mobility, and even some sort of opposability.[3]

Championing the 'great toe' as 'civilized' and, indeed, even efficacious in 'uncivilized and barefoot people' (we are worlds away from Bataille here), Huxley would seem to contradict his self-declared privileging of the hand over the foot.[4] Either way, his comments take us into the milieu of barefooted, elite running, the subject of this chapter, where the 'barefoot' is often linked to ethnicity; and where the 'great race' and the 'race' of the runner become entangled in a mixture of cultural and political issues, some extraordinary, others commonplace.

BORN TO RUN

Running barefoot has a long history dating back to ancient Greece – but modern, professional, headline-achieving athletes choosing to run without footwear in international meets first came to attention in the 1960s, through runners like Abebe Bikila (Ethiopian) and Zola Budd (South African). This nascent, barefoot running phenomenon (sometimes called 'natural') was given momentum by the publication many years later in 2009 of Christopher McDougall's *Born to Run: A Hidden Tribe, Superathletes, and the Greatest Race the World Has Never Seen*. Central to the book's narrative are the Tarahumara, a Native American people of north-western Mexico who have a particular talent for long-distance running wearing only simple sandals – not quite barefoot, but ever so close. This fascinated McDougall. Contrary to *Born to Run*'s claims, however, the Tarahumara runners (the so-called 'hidden tribe' of the book's title) were already reasonably well known in running circles.[5] As the writer Scott Douglas has pointed out, they had been 'part of running lore for decades.'[6] 'When I started reading running magazines in the early 1980s,' Douglas says,

> the Tarahumara were presented more as common knowledge than as paradigm-changing discovery. In 1993 and 1994, many runners now know, members of the Tarahumara won the Leadville Trail 100 Run, a 100-miler in Colorado.[7]

Professional jealousy in the literature on barefoot and so-called minimal running seems to me clear. Equally clear is the fact that after

the publication of *Born to Run* in 2009, barefoot running began to attract increasing numbers of followers. In November of that same year, the Barefoot Runners Society was founded in the USA; one year later, in 2010, its members had almost doubled, from 680 to 1345 – small but significant.[8] The year 2010 also saw the republication of *Born to Run*, with much the same title, but replacing 'Superathletes' with the 'Ultra-runners'. Referencing races that exceed the traditional marathon length of 26.219 miles (42.195 km), the term 'ultra' takes the 'Superathletes' into a more rarefied world. Yet, as Douglas points out, 'Many runners also know that aptitude in trail ultras at altitude is one of several forms of running competency, not the *ne plus ultra* of athletic accomplishment.'[9]

Born to Run is a mixture of the scientific and the impudent, the colloquial and the humorous; and all this is couched in fuzzy meditation redolent of an earlier era and its (literary) representation in Robert M. Pirsig's *Zen and the Art of Motorcycle Maintenance* (1974), a bestseller which has sold over 500 million copies. Take this passage from *Born to Run*:

> Before setting out for their sunset runs, Jenn and Billy would snap a tape of Allen Ginsberg reading 'Howl' into their Walkman. When running stopped being as fun as surfing, they had agreed, they'd quit. So to get that same surging glide, that same feeling of being lifted up and swept along, they ran to the rhythm of Beat poetry.[10]

Like *Zen and the Art of Motorcycle Maintenance*, McDougall's book received rave reviews: 'The *best* book on running I've ever

read,' opined Shankarah Smith, manager of London's Run and Become, a specialist running store; 'A fascinating meditation on man's urge to run,' said *Men's Health*.[11] (*Born to Run*, incidentally, is the title of Bruce Springsteen's hit single from the album of the same name that catapulted him to fame in 1975; McDougall would have recognized this and no doubt even hoped to capitalize on the association. Ironically, the lyrics of 'Born to Run' are dark and dystopian, the antithesis to McDougall's uplifting and 'life-affirming' narrative).[12]

RUNNING AGAINST RACE: ABEBE BIKILA

Born on 7 August 1932, in a village called Jatto in the North Shoa region of Ethiopia, Abebe Bikila; his brother, Kinfu Bikal; and sister, Aschaetch Termtime, were brought up in a rural environment in which his father was a shepherd.[13]

'Years later, when Bikila was known throughout the world,' writes Tim Judah in his recent biography of Bikila,

Colin Gibson of World Sports magazine went to Ethiopia to interview him. He wrote that, 'as a barefoot young shepherd-boy minding his family's herds, Bikila was used to walking and running several miles every day in search of grazing on the lava-strewn crags surrounding his home. At 13 he went to school and played ganna, Ethiopia's long-distance version of hockey, with the goalposts in the opposing teams' villages – maybe a couple of miles apart.'[14]

In 1951 Bikila moved to Addis Ababa, the capital of Ethiopia. There he joined the Imperial Bodyguard which, as its name suggests, was established to protect Haile Selassie, Emperor of Ethiopia. Bikila's athletic prowess, especially his ability to run long distances with ease, was soon spotted by the Bodyguards' sports trainer, the Finnish-born Swede Onni Niskanen, who saw in Bikila a potential marathon runner. Niskanen's presence in the country was far from fortuitous: on the contrary, in 1924, the young Ras Tafari – later to become Haile Selassie – visited Stockholm; after the Second World War, now Emperor and 'not wanting to be dependent on either the Americans or the Soviet Union' and 'keen to break off the British military tutelage that had been established over the country after the expulsions of the Italians in 1941', Selassie re-established links with Sweden that would see, inter alia, the appointment of Swedish officers to organize a cadet school to train the officers for the Emperor's Bodyguard.[15] It was here that Niskanen, a reserve officer and a qualified sports instructor, would find a niche; by 1950 he was ensconced as director of physical education at the Ministry of Education.

This confluence of geopolitical and sporting factors established a sympathetic climate in which Bikila thrived. A similar convergence in the case of the South African Zola Budd, a celebrated middle- and long-distance runner, would, years later – as we shall see – have very different results. That sport and politics are forever separate and distinct is nonsense. Their shared intimacies, however, do wax and wane depending on circumstances.

Eight years after his appointment, in 1958 Niskanen returned to Sweden with three runners – Bikila, Mamo Wolde and Said

Mussa, determined to prepare them for the Olympics in 1960. As events turned out, however, Niskanen would actually turn to other runners – Abebe Wakgira and Wami Biratu. Yet the unfortunate breaking of his ankle in a football match resulted in Biratu being replaced at the last minute by Bikila, who suddenly found himself on the plane from Addis Ababa to Rome.

Bikila found the running shoes given to him in Rome uncomfortable. Provided by Adidas, the shoe sponsor of that year, he set them aside in favour of running barefoot. (What, one wonders, did Adidas make of this? It was a slap in the face, at the very least, as well as a marketing denouement, in more dramatic terms.) Bikila's audacious decision to abandon the running shoes, to repeat, was triggered by a circumstance both prosaic and fortuitous. But it was also a decision that sat comfortably with the ways in which Bikila had prepared for the race – running without shoes. This would become essential to his legacy: the first East African to win an Olympic medal – gold to boot – and the first to do so running barefoot.

There is another noteworthy 'first': the Rome Olympics was the first to be fully covered by television, both in the USA (through taped footage broadcast by CBS) and in Europe (via live broadcasts on Eurovision). This provided an extraordinary context for looking at, and listening to, an event that, as the marathon-obsessed runner and writer Robin Harvie has correctly pointed out, was an Olympics 'thick with political overtones', a feature in no small way due, I suspect, to the fact that 1960 marked the beginning of the end of colonialism in Africa.[16] To name just four colonies that achieved their independence early that year before the

commencement of the Olympics on 25 August: French Cameroons (1 January), British Cameroons (1 June), Mali Federation (20 June) and Belgian Congo (30 June).

There is a film of the Rome Olympics marathon in colour and with commentary (in Italian) that is accessible through YouTube.[17] I do not know who produced it nor for whom, although I suspect it is official footage. This same footage (plus additional introductory material) appears in higher definition, and with English commentary – also available on YouTube, it is the version to which I will refer.[18] Shots of the heroic equestrian sculpture of Marcus Aurelius, Roman emperor from 161 to 180, set against blue skies and triumphal music that continues throughout the film – I'm reminded of Fascist scenarios of the 1930s and '40s – establish the scene. Fidgety runners are waiting to start. Over the course of the race, we see significant 'pieces' of history, including the Victor Emmanuel monument, the Colosseum and where the race concludes, the Arch of Constantine. This regulation marathon of 42.195 km (26.22 miles) brings together history and modernity in seductive ways that will serve as a model for all subsequent Olympic marathons.

It is late afternoon on 10 September 1960. Bikila, number 11, in black vest and red shorts, begins slowly, but then breaks off from the throng and joins the first group consisting of six that nearly halfway through the race drops to four. At the commencement of the race, however, the commentator in his stereotypically English upper-class tones, had opined, 'Who is that quiet Ethiopian?' Later in the race, the phrase is repeated: 'and the quiet, unknown Ethiopian we saw at the start ...'[19] Considered in a wider context,

31 Ethiopian athlete Abebe Bikila runs barefoot for victory in the 1960 Summer Olympics marathon in Rome, after passing Moroccan Rhadi Ben Abdesselam.

these comments seem inextricably linked with colonialism and, by contrast, its continuing – and dramatic – dissolution. Let's go back to the race, however: aerial views, vehicles running alongside or behind the runners and cheering onlookers fill the frame. Recognizing that Bikila is a runner to be reckoned with, the cinematographer, meanwhile, has been drawn to Bikila's bare feet, which hit the ground methodically and gently: close-ups show dirt on Bikila's soles, a tender reminder of the foot and its intimate connections with the soiled surfaces of our world. When twilight sets an hour or so later, Bikila and the Moroccan Rhadi Ben Abdesselam, number 175, are comfortably in front. Says the commentator, to complement this sequence, 'in Africa it is the time when the animals drink.' Of course, commentary can be edited,

and often is. This makes the observation more telling, evoking as it does a manageable and exotic image of Africa, one consistent with what Edward Said would later write in his pioneering *Orientalism* (1978), about the West's patronizing and fantasizing representations of other cultures.[20] When the black night sets in, it becomes a Fellini-like spectacle: sections of the marathon route are illuminated, while flickering torches are held aloft along the Appian Way, the strategically important and canonical road of the ancient republic of Rome. With about 1,000 m to go, Bikila pulls away from Ben Abesselam. He touches the tape and lifts his hands, almost reluctantly, once, twice. Moving among the crowd, he limbers up – so it seems – and bends and touches his toes, once, twice, three times. Bikila's time is a record 2 hours, 15 minutes and 16.2 seconds, 8 minutes faster than Emil Zátopek, Czechoslovakia's famous long-distance runner who won three gold medals at the Olympics 1952 in Helsinki (illus. 31).

BIKILA'S REMARKABLE AND UNEXPECTED win, and the Moroccan Radhi Ben Abesselam coming second, singled out Africa as a new and hugely competitive force. Writing about the marathon from above – literally (he was in a helicopter) – Robert Parienté of *L'Équipe*, a French sports newspaper, would say,

> I saw Rhadi [Ben Abesselam] go ahead and then I saw a black man who was running barefoot. We did not know who he was. Then we looked at the lists and did not know if his surname was Abebe or Bikila.[21]

This befuddlement, it seems to me, captures the ethos of colonialism in pithy ways: 'who *is* this black man and what *is* his name?' The subjugated is never really known. Moving forward many years to Washington, DC, in 2009, to a postmodern piece of humour, the US actor and comedian Robin Williams referenced Bikila in a stand-up performance titled 'Weapons of Self Destruction':

> My favourite athletes of any Olympics are always [the] African distance runners . . . One of my favourite runners of all time was Abebe Bikila; he was an Ethiopian distance runner and he won the Rome Olympics running barefoot; he was then sponsored by Adidas. He ran the next [Tokyo] Olympics – he carried his fucking shoes![22]

Though not especially funny when read, it is hilarious when seen and heard. To put the record straight regarding the Tokyo Olympics of 1964, however, it should be noted that Bikila did, in fact, wear shoes (along with white socks, blood-red shorts and a black vest with the number 17). The shoes were Pumas. Bikila won the marathon in 2 hours, 12 minutes and 6 seconds; Basil Heatley (British) came second and Kokichi Tsuburnerd (Japanese) third. These niceties, however, are not my point; I am more concerned with the ways in which Bikila entered popular culture. Take the thriller *Marathon Man* (dir. John Schlesinger), from early 1976, which carried flashbacks to Bikila winning the Tokyo marathon in 1964, footage that itself was taken from the film *Tokyo Olympiad* (dir. Kon Ichikawa, 1965), a critically acclaimed sports documentary that focused inventively on the particularities of athletes, spectators

32 Vibram, FiveFingers Bikila model, 2010.

and attendants. And what are we to make of Vibram, an Italian company based in Albizzate that introduced the Bikila model of its so-called 'minimal shoes', which separated toe components into 'five fingers', in 2010? Consisting of little cushioning and no arch support, the 'Bikila' promoted itself as a shoe that was not a shoe but one that came as close to running barefoot as possible. 'Sci-fi grotesque' in appearance, as I would describe it, the 'Bikila' fetishizes the 'racing foot' in ways that pretend to be an offshoot of the 'hand' (hence the epithet 'five fingers'), and yet it is as close as possible to the unadulterated bare foot (illus. 32).

FEELING THE TRACK/RUNNING THE RACE:
ZOLA BUDD

I found [shoes] uncomfortable and after that I decided to continue running barefoot because I found it more comfortable. I felt more in touch with what was happening. I could actually feel the track.[23]

This frank statement by the South African-born middle- and long-distance runner Zola Budd about running unshod belies the considerable impact her racing, ethnicity and citizenship would have both on her personally and on her wider role in world athletics. Putting one's best foot forward is never as simple as it would seem.

Zola Pieterse (née Budd), now living with her three children in South Carolina, USA, was born in 1966 in Bloemfontein, South Africa, at the height of Apartheid. Running regularly from a young age, and achieving many notable victories in her home country, she would go on to represent Great Britain in the 3,000 metres at the Olympics held in Los Angeles in 1984. Budd's sudden acquisition of British citizenship would prove to be hugely controversial, as would her decision to run barefoot. Superseding but intimately linked to these matters was the dramatic event that occurred during the 3,000-metres race in Los Angeles, when Budd and her American rival and favourite, Mary Decker, memorably collided.

The death of Zola Budd's beloved sister Jenny, a nurse, to melanoma on 9 September 1980, when Budd was only thirteen, had, as she says, 'a profound influence on my life and running career.'[24] Born in 1955, Jenny Budd was the oldest of the six siblings: Estelle (b. 1957), Frankie (b. 1960), the twins Cara and Quintos (b. 1961), and Zola. In effect, Jenny would become a surrogate mother, an antidote to a developing estrangement between the children's parents, who would divorce in 1980, the year that Jenny died.

Ten days after Jenny's death, Zola ran and came fourth in a 3,000-metres race in Bloemfontein; in light of her very strong love

for her sister, this testifies, if nothing else, to her dispassionate focus as a professional runner.[25] Two years later, and urged on by her coach, Pieter Labuschagne, Zola won the national under-nineteen 3,000 metres and 1,500 metres championships.[26] There were many other successes in 1982, but the year's 'highlight', as she writes, was

> learning that I was to be awarded Springbok colours for track and field. It was a proud moment when I put on the famous green and gold blazer, but the occasion was marred by a row between my family and coach.[27]

The reasons for this 'row' lie beyond the scope of this chapter – suffice it to say that the relationship between parents, coach and runner had always been uneasy.[28] Zola Budd came from a farming background, in which walking or running barefoot was commonplace:

> I saw nothing out of the ordinary in running barefoot, although it seemed to startle the rest of the athletics world. I have always enjoyed going barefoot and when I was growing up I seldom wore shoes, even when I went into town. The exceptions were when I went to school or to church or on special occasions, and it was natural when I started running that I should do it barefoot.[29]

There is an amusing anecdote here: on her arrival in England (see below), Zola developed a love of English teashops. She could

'drink tea until the cows come home.'[30] On one occasion, when her gear was elsewhere and she had no shoes, she went into a tearoom barefoot, as she would have done in Bloemfontein: 'I got some strange looks. "Oh Dear," the people inside seemed to be saying, "the poor child. What's she doing here without shoes?"'[31]

Zola would receive her first pair of running spikes when she was thirteen. Using them in inter-school athletics meetings, she

> found them uncomfortable and after that I decided to continue running barefoot . . . I felt more in touch with what was happening – I could actually feel the track – and it wasn't until the cross-country season [in 1980] that year that I got my first pair of proper training shoes.[32]

These 'proper training shoes', however, did not stop Zola running barefoot and winning, for example, the under-sixteen 1,500 metres at the annual Bill Troskie in Bloemfontein in February 1981, a photograph of which in Zola's autobiography shows her and her rival, Stephanie Gerber (b. 1966), both running without shoes: the slightly built Zola, number 31 – as the caption says – is 'one step ahead' of Gerber, number 30, whose feet, in the photograph, seem to levitate above the track.

The years 1982 and 1983 saw Budd achieve remarkable track victories: 24 in 1982 and 26 in 1983, the most successful year of Budd's career.[33] These, of course, took place in South Africa, in towns and cities like Bloemfontein, Sasolburg, Germiston, Port Elizabeth and Cape Town. Budd was only seventeen in early 1984 when she ran the race of her life in Stellenbosch, Western

Cape, on 5 January. It was 5,000 metres, the night windy and the spectators hugely supportive. Budd was on top form. Feeling the crowd 'urging' her on, she went through 1,500 metres in 4:21:1. At that stage, Budd says,

> the commentator announced that I was on world-record pace. An athlete often does not hear the stadium's commentator during a race, but on that night it got through to me. 'Oh No!' I thought. 'How am I going to run another eight laps when I'm already so tired after four? . . . That's where my conditioning came in . . . At the bell [on 400 metres] I was gasping for breath thinking only of the finish and wishing the torture was at an end.'[34]

Apocryphal or not, Budd's account of her winning the race in the remarkable time of 15:01.83, beating her rival-from-afar, the American Mary Decker, by 6.54 seconds is compelling.[35] A black-and-white photograph reproduced in her autobiography shows Budd determined, focussed but clearly under pressure, running barefoot: 'At seventeen I was the fastest woman in the world and as the news flashed around the globe I was to become one of the most sought-after women in the world.'[36] This is bravura, certainly. But it is not far from the truth — and here I jump forward in time to another photograph in Budd's book: it shows her seated with her coach Pieter Labuschagne at a press conference in Oslo. It is May 1984, shortly before the 10-km road race against the likes of Norwegians Ingrid Kristiansen and Grete Waitz, outstanding long-distance runners. Zola Budd, standing on the right of

Labuschagne, wears large glasses, typical of the time. Dwarfed by her moustachioed coach, she leans slightly back and to her left, all the while looking, eyes wide open and lips slightly parted, to our right. Here she is not a picture of self-assurance but rather one of diffidence, of uncertainty.

To return to the early months of 1984, however, when, in the wake of Budd's remarkable world-record-breaking 5,000-metres race, she was inundated with offers, including scholarships and citizenship, from – among others – the USA, Italy and the UK. Negotiations ensued involving Budd's father, Frank, and various South African business persons, and a certain Bill Muirhead eventually became adviser to the Budd family.[37] Meanwhile, others were looking into the possibility of exploiting Zola Budd's ancestry – especially the fact that her grandfather was English. To put this in context, Budd, like all other South African athletes, was banned from all international competitions. So when the Olympics of 1984 beckoned, and the young Budd was seen as a potential international champion, marketing and managerial forces around the world became active. Included among these was the cunning conservative British tabloid the *Daily Mail*, whose special correspondent Brian Vine and athletics writer Neil Wilson were sent to South Africa to see if they could negotiate – and that is the operative word – a deal to get Budd to the UK, where she could then become a British athlete and be eligible to participate in the forthcoming Olympics. Zola Budd's British roots were to be at the heart of this matter: her paternal grandfather was an Englishman, Frank George Budd, while her great-grandmother, Janet McGibbon, was the daughter of Scottish parents. That these

'British roots' were less than compelling, however, never stopped the internecine manoeuvres, which finally led to Budd acquiring a British passport in remarkably quick time and, together with her family, departing for England on 24 March 1984. On the eve of her eighteenth birthday, Budd entered into a difficult phase in her life – albeit one that would have its (professional) high points.

Seeking to secure exclusive rights to Budd, Sir David English, the editor of the *Daily Mail*, boasted that he could 'pick up this phone and get her a British passport in two days . . .'[38] In fact, as David Burnton wrote in *The Guardian*,

> it took 10 [days]. First he [English] had to get the Budds on board, which he did by offering them a house, £100,000 in cash, a job for Frank, a lucrative deal for Zola to write an Olympic diary, and by promising to bring over her coach, Pieter Labuschagne. The family were flown to Amsterdam, and then by private jet to Southampton . . .[39]

Throughout Budd's autobiography, to which I often refer, she makes a case for herself as a reluctant and exploited young woman, thrown hither and thither in an adult world that never really understood, or sought to find out, what she felt as an adolescent – who hardly spoke English – about moving to the UK, and all this notwithstanding her remarkable athletic talents. I would, though, draw attention to this telling observation by Steve Friedman, with which I agree:

Mention the name Zola Budd to the casual track fan and you'll likely get one (or all) of three responses: Barefoot. South African. Tripped Mary Decker. Those were the boldest brush strokes of her narrative, and they continue to be. But the legend of Zola Budd is, like all legends, simple and moving and incomplete. It is made of half-truths, exaggerations, and outright lies. *She did run barefoot – but so did everyone else where she grew up. She did refrain from speaking out against great and terrible injustice – but so did a lot of other people older and wiser.* She did suffer stunning setbacks and tragic losses, but much of her misfortune was worse than people knew, the losses more complicated and painful than most imagined.[40]

Establishing a persuasive context for the Budd 'legend', these pithy comments allow me to return to her acquisition of a British passport, which many in the UK at the time felt was fast-tracked simply to allow her to represent Britain in the Los Angeles Olympics in 1984. As I've said earlier, the Zola Budd case brought together race (in both senses of the word) and politics, added to which were money and (misguided) patriotism. All in all, it was a potentially inflammatory combination.

As stated, the *Daily Mail* was instrumental in bringing Budd to England. This widely read conservative tabloid carried articles by the likes of the popular gossip columnist Nigel Dempster and the much-beloved sports writer Ian Wooldridge, who, unlike some of his colleagues and in contrast to the newspaper's general line on not backing sporting boycotts of South Africa,

was strongly critical of Apartheid. On the death of Wooldridge in 2007, Frank Keating wrote a long and affecting obituary in *The Guardian* – certainly a newspaper not ideologically aligned to the *Mail*. Keating, understandably, drew attention to Zola Budd, writing,

> Ian readily and regularly debunked the Mail's 'let's play with apartheid' editorial policy, and he refused to join in his paper's cynical and contriving stunt with the South African runner Zola Budd ... [41]

Underpinning the *Daily Mail*'s actions, however, was this paradox: yes, they were 'cynical and contriving', and yes, they were sure to attract much publicity, both good and bad; on the other hand, the newspaper could be seen to be assisting a young and hugely talented white South African athlete to spread her wings via what the *Mail* would argue were perfectly proper processes. Acting as Budd's facilitator, it arranged for her to join the Aldershot, Farnham and District Athletic club. Soon thereafter, the *Mail* helped organize a 3,000-metres race at Dartford (14 April 1984), simply because to qualify as a British citizen, Budd had to meet the Olympics qualifying time for this distance, notwithstanding the fact that she had already achieved this in Stellenbosch, back home, two months previously. At Dartford, Budd was required to wear spikes given to her as a gift – I do not know by whom.[42] At any rate, she came first, with a junior UK record of 9:02:6.

A photograph in Budd's autobiography shows her with British officials Nigel Cooper and Marea Hartmann on the day she received

her British passport. Cooper's right hand placed awkwardly on Budd's right elbow, or thereabouts, and his other hand behind but clearly putting pressure on her arm, construct, it seems to me, an image of manipulation that shows an insecure young woman sandwiched between a beaming fatherlike adult and an equally beaming maternal woman. As I've suggested previously, we are not dealing with a picture of a confident young runner, but rather, as we see in the image currently being discussed, a young woman in sober dress – situated between two equally soberly dressed adults – who looks at us with a frigid smile, frozen, it would seem, in an environment alien to her.

More recently, the British government released documents that revealed the extent to which the Budd 'affair' polarized the Thatcher administration. The Foreign Secretary, Geoffrey Howe, recognizing that 'sport and South Africa is a political minefield', felt that rushing to grant Budd a passport would look 'unseemly'.[43] The Home Secretary, Leon Brittan, ignored these sentiments. Documents also show that by March 1984, David English, the aforementioned editor of the *Daily Mail* (what an appropriate surname!) had personally put pressure on a number of ministers to give Budd a passport. As Neil MacFarlane, the then Sports Minister, put it to Brittan, 'David English left me in no doubt last night that he is prepared to use all his contacts to secure entry for Zola Budd and we can anticipate a *Daily Mail* crusade.'[44] A flurry of exchanges between ministers ensued. In a communication to the British Ambassador in South Africa on 22 March, only a few days before Zola and her family would arrive in the UK, Howe wrote, 'we share your misgivings about the

implications' of giving Budd a passport, but added that there were 'strong domestic political considerations which have influenced ministers.'[45]

BAREFOOT, BUMPING AND HULLABALOO:
THE LA OLYMPICS OF 1984

Zola Budd was *brought* to England and within two weeks of her arrival, on 5 April 1984, she received British citizenship, at a time when applications for a passport took a year on average.[46] 'Brought', an unseemly word, which I place in italics, is, I think, in this instance appropriate. Salvaging Budd from a racist regime, and providing her with a British passport (so the rhetoric of the *Daily Mail* went), would allow her to participate in the LA Olympics; of course, she would then go on to win the 3,000-metres race that involved, among others, the famous Mary Decker from the USA. This was the *Daily Mail*'s agenda that, for reasons wholly unexpected, would never materialize.

Budd did not look forward to this race. The pressures on her were enormous – there was pressure from her family, as well as widespread media expectations, including, of course, from the *Daily Mail*. There was, however, if Budd's autobiography is to be relied upon, 'one bright spot' on the day of the race,

> when the athletes in the 3,000 metres final had to show their running shoes to an official, whose task it was to see that the spikes conformed to specifications. I was barefoot, so I just picked up my feet and showed them to him, white plasters on

my toes and all. The poor man nearly cracked up laughing, but what else could I have done?[47]

The self-effacing nature and dry humour of this admission sits comfortably with my understanding of Budd – as do her comments on how the 'Decker v Budd showdown' and the chanting of 'Mary, Mary' that went on before the race created an atmosphere that for the young Budd was, at the very least, unsettling.[48] That said, however, how could it have been anything else? There is more than a smack of the ingénue in Budd's autobiography.

Zola Budd's account of the race and her collision with Decker, which resulted in the American falling with three laps to go and having to withdraw from the race, fills only four pages of her autobiography, a little on the short side of what one might expect in light of the extraordinary media coverage of the event both at the time and after. But for Budd herself, perhaps with hindsight, the controversy surrounding the incident had exceeded the very simple and human nature of the accident. Budd is nothing if not matter-of-fact in her version of the collision.[49] In summary, she says that the pace was slow, and the front runners began to bunch. Decker was in the lead; Budd was outside her and the Romanian, Maricica Puica, behind. Britain's Wendy Sly, who, surprisingly, was overlooked in the aftermath of the race, loomed up on Budd's outside, crowding her and 'bumping' her arm. Budd 'started accelerating to get out of trouble'. Thinking that the 'inside lane was open', she 'moved across the track'. And, well, the rest is history (illus. 33).

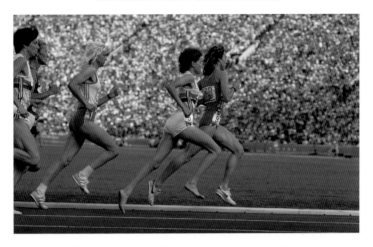

33 Mary Decker just ahead of Zola Budd, 1984 Summer Olympics, Los Angeles.

Television coverage focused on replaying 'the fall' so much that few knew the medalists. Gold went to Romania's Maricica Puica, with Britain's Wendy Sly and Canada's Lynn Williams taking silver and bronze, respectively. [Budd came seventh.][50]

As an afterword, I've looked closely at a film of the race with commentary by David Coleman and Brendan Foster, and I go along with Budd's account.[51] Decker is the first to show, with Budd on the outside, coming second. The first lap is 'quite quick' (67 seconds). Meanwhile, Puica is third. With five laps to go, Budd and Decker seem at ease, running comfortably. At approximately 4:41:9, Budd moves to the front, having had Sly on her right and Decker on her left, seemingly to box her in. A commentator observes that Budd's 'wide elbow and arm action [are] not easy to get around'. Viewing

this film, I think this is correct. Very soon afterwards, the collision takes place.

In November 2012, a young black South African journalist, Iphepha, caught a minibus taxi in Soweto; she was surprised but delighted to hear a song by the South African Afropop icon Brenda Fassie (1964–2004). It was the 'Zola Budd' song which, Iphepha says, 'was so popular and spoke to almost every facet of South African Society at the time, then in the 1980's Apartheid South Africa'.[52] The lyrics she quotes are:

Bhuti (brother) Ngiceli' lift (can I get a lift) [Iphepha's translation]
In your Zola Budd, Zola Budd, Zola Budd!
I wanna be in your Zola Budd, Zola Budd, I want
To be in your Zola Budd, Zola Budd, Zola Budd!

Certainly, on listening, it is an engaging song replete with African rhythms denoting a rich musical heritage. Taking its subject from a new fleet of the aforementioned minibus taxis (used back then largely by black South Africans) named 'Zola Budd' (because they 'were just as fast!' as the famous barefoot runner), the song, devised and delivered by an audacious black activist/singer, struck a chord with both black and white South Africans of different political persuasions at a time when the government was forced to declare two states of emergency in response to increasing opposition to Apartheid.[53] If 'race' and 'race', my conceit, were ever to be used interchangeably and with serious intent, then this was its imaginative moment.

The Filmic Foot

I n 2010 the London-based screenwriter Tess Morris wrote a short piece for *The Guardian* in which she 'trips through the best foot footage on film'.[1] She cites five examples: *Die Hard* (1988), *Misery* (1990), *The Big Lebowski* (1998), *Bull Durham* (1988) and *Jackie Brown* (1997). Directed by Quentin Tarantino, whose preoccupation with the female foot is well known, *Jackie Brown* is a film I'm certainly aware of, but I do not discuss it in this book, choosing instead to focus on *Kill Bill: Volume 1* and 2 (2003 and 2004, respectively) and, more recently, *Inglourious Basterds* (2009). None of Morris's five films match mine. For that matter, perusing the 'Top Ten Foot Fetish Movie Scenes' (written by 'feethunter' on 27 December 2014), I see that my list includes only one named there – *Lolita* (1997), although I subsequently left it out:[2] notwithstanding its eloquent opening sequence, with credits rolling over the hand of a man who is gently handling a (female) foot and applying varnish to its toe nails, the film's (female) feet symbolism is contrived. Others mentioned in 'Top Ten Foot Fetish Movie Scenes' include *The Principles of Lust* (2003) and *Johnny be Good* (1988), films I have never heard of, let alone seen.

Listing the best 'foot films' is futile. That said, I return to Morris's piece in *The Guardian*, where she writes wittily but with sure understanding:

> Feet just don't get enough praise in life, let alone in cinema. Nothing says funny, sexy, thrilling or horrific like the naked foot. They're the most versatile prop a film-maker can use – be it for running, jumping, skipping, flirting or roundhouse kicking someone in the face. Indeed, the bare foot in film is so powerful that it can even be massaged offscreen [the reference here is to *Pulp Fiction*] and still steal the show. Let them run free and both feet, one foot, just the toes (or even just the one toe) will put every other body part in the shade. The audience can relate to feet – hey, I've got those! – then imagine their own pair being hobbled. Yep: fetishized or not, elegant, sensual or just down right stinky, the humble foot has certainly secured its place in cinema history.[3]

These perky observations go beyond the genre of 'film and feet' into a more subtle narrative that touches on what is at the core of my book – the foot and its imaginative promise. The first of my three themes, 'Natural Feet', begins with *Modern Times*, that iconic film starring, directed and written by Charlie Chaplin and released in 1936. This is followed by *The Adventures of Huckleberry Finn* (1939) and, fifty years later, *My Left Foot* (1989).

NATURAL FEET

A bravura mix of comedy and social commentary, *Modern Times* casts an acerbic eye over a range of topical issues set against the Great Depression of 1929: industrialism, unemployment, gender roles, domesticity, consumption and authority.[4] Deemed 'culturally significant' by the Library of Congress in 1989, the film represents the swan song of Chaplin's well-loved character, his own alter-ego, the 'Little Tramp', a gentleman cum down-and-outer who does his very best to survive the vagaries of the modern world. It is not the 'Tramp' that attracts me, however, but rather, his partner in (gentle) crime and object of strong – albeit uncertain – affection: the girl/woman, a 'gamin', as she is described in the opening credits, played by Paulette Goddard (1911–1990).[5]

As her 'title' suggests, the 'gamin' is a teasing, wide-eyed, roguish girl/woman of indeterminate age, who (physically) never seems to change, but her circumstances certainly do. When we first come across her, she is dressed in a knee-length, flimsy dress. Described as 'a child of the waterfront who refuses to go hungry', she is shown furtively cutting into a bunch of bananas with a knife that she then plants in her mouth – biting on it, menacingly, but with an impish smile.[6] She throws some of the fruit to a group of excited children on the dockside; very soon the proprietor arrives and chases her off his boat. The sequence ends with her standing legs apart while chewing on a banana and looking furtively around (illus. 34). As with all the other characters in *Modern Times*, the gamin remains nameless (the generic term aside). Central to the film's narrative, she becomes, in effect, the Little Tramp's muse: a close friend and

confidant, an accomplice and (imagined) wife. Initiator of all things good, gamin/Goddard encourages Chaplin to get a respectable job, something that he had always frowned upon. More problematic, it seems to me, is that the gamin comes close to being a combination of daughter/wife/sexual object: Chaplin's fatherly gestures and his frolicking with her in a department store, where there are toys and skates and a wonderful, comforting bed – which the Tramp insists that Goddard sleep in (for the best of reasons, I should say: his wish for her to sleep, finally, in a lovely bed) – but where, wrapped in a white (fur?) robe, she takes on an unmistakable aura of an 'innocent' Hollywood star.

It is the gamin's feet, of course, that interest me. First appearing shoeless in the waterfront scene, as we have seen, she continues in

34 The gamin (Paulette Goddard) on the waterfront in *Modern Times* (dir. Charlie Chaplin, 1936).

this manner until, in the department store (where the Tramp now has a job as a night porter), she puts on skates. The Tramp follows suit and then proceeds, blindfolded, to skate with balletic charm but ultimately coming very close to a disaster. Leaving the store surreptitiously in the early morning, Goddard is back in her bare feet. When she and the Tramp next meet, it is after his (short) imprisonment (because of his misdemeanours in the department store), and the scene is now a makeshift 'cabin' where, once again barefoot, the gamin does her best to act as the reliable and loving wife, cooking them both a frugal but mouthwatering breakfast. During yet another period of incarceration for the Tramp, the gamin, dressed again in the slinky dress from her first appearance, dances – once again barefoot – on the waterfront. A nearby café

35 The gamin, well dressed, in *Modern Times* (1936).

owner, looking on admiringly, says, 'She'd be good for the café.' Employed, but now wearing what seems to be a lamé dress and ballet shoes, she dances away happily and to much applause. Evidently having earned decent wages, 'one week later' we see her waiting outside a police station for the Tramp, who had yet again been incarcerated. This time, however, the gamin is all prim and proper: she wears a hat, tailored skirt and flat-heeled shoes (illus. 35). I leave *Modern Times* here, at the point where the gamin has (seemingly) become gentrified. No longer foot loose and fancy free, she has morphed into a genteel woman – but not quite: *Modern Times* concludes with the Tramp and the well-dressed gamin walking along a road into the distance, their futures unknown. They are prototypes of the 'Western hero' disappearing into the horizon. It is a mawkish but affecting sequence.

In 1939, three years after the release of *Modern Times*, the MGM movie *The Adventures of Huckleberry Finn* (dir. Richard Thorpe)[7] had to compete with a string of films that were hugely successful at the box office, including *Gone with the Wind* and *The Wizard of Oz*. It did not do that well. Yet this version, starring the immensely popular Mickey Rooney (1920–2014) as 'Huck' and Rex Ingram (1895–1969) as Jim, a slave and friend of Huckleberry who is running away from slavery and hoping to end up in Cairo, Illinois – Illinois being a Free State – is probably the best known and most popular of the many filmic adaptations of Mark Twain's novel of 1885. Included among these are adaptations from some unexpected places such as the Soviet Union (*Hopelessly Lost*, dir. Georgiy Daneliya, 1972), Japan (a Japanese anime series in 1976) and, more recently, Germany (*Die Abenteuer des Huck Finn*, dir. Leon Seidel, 2012).

36 Huck's (Mickey Rooney) foot and its bandage, in *The Adventures of Huckleberry Finn* (dir. Richard Thorpe, 1939).

A tightly scripted film that erases Tom Sawyer from the narrative, *The Adventures of Huckleberry Finn* (henceforth referred to as *The Adventures*) is set against the USA in the late nineteenth century and the social geography of the great Mississippi River. A rambunctious film, it deals lightly with questions of slavery, social conventions and white privilege. Important as this is, the narrative still constructs Jim as an obsequious servant (even when he is on his way to freedom), and Huckleberry at times as a boy with good intentions but rooted in his society's prejudices. Above all else, however, it is a tale of youth and its carefree, rebellious and idealistic disposition – at any rate, how this was understood in the late 1930s, at a time of economic turbulence and military conflict.[8]

Feet and *The Adventures* go hand in hand – specifically, bare feet, a recurring motif that sits easily with adolescent notions of freedom, rebelliousness and mettle. Our first encounter with Huck is, in fact, with his right foot – or, more precisely, his big toe,

which has a bandage or a 'reminder', wrapped around it (illus. 36).
Panning slowly left, the camera reveals a dozing young man, pipe in
mouth and wearing a straw hat on the banks of a river. Very soon
friends of Huck's – school chums – appear, some of whom proceed
to take off their shoes, a recurring theme in the film. This scene
establishes some central narratives: at his school, Huckleberry is
considered a nonconformist, even a bit of a rebel; his alcoholic
father has left him and may or may not be dead. Huck is looked
after by the kindly Widow Douglas and her surly sister, Miss
Watson. Leaving the idyllic setting at the riverbank, Huckleberry
rushes home for dinner: on arriving, he quickly begins to put on
his socks and shoes, helped by the servant Jim. Finding that he has
misplaced one of his socks, Huck hurriedly puts his bare foot into
his shoe. Eventually settled at the dinner table, he is quizzed by

37 Huck fidgeting, in *The Adventures of Huckleberry Finn* (1939).

Miss Watson: where was he? What was he doing? Huck's reply is a white lie; Miss Douglas understands as much, but is supportive, while Miss Watson remains convinced. Shortly thereafter, in a different setting, she smells smoke and accuses Huck of smoking, which he strenuously denies.

It very soon becomes clear to Widow Douglas that Huckleberry is a liar, albeit an engaging one. So Miss Watson invites him to sit down on the steps of a staircase and explain his actions. A shot of a fidgety bare foot in a shoe alongside a socked one (illus. 37) introduces Huck's response:

> Well, ah, I think it's mainly on account of the shoes, I think
> … You see, shoes and my feet don't seem to get on together;
> I guess it's 'cause I ain't worn them that much, and, I mean,
> don't your toes get hot?

This explanation, sly to be sure, should be set against Huckleberry's earlier encounter with Jim, in which, sitting with him under a tree in the evening, he engages in a (convoluted) discussion about slavery and Jim's suggestion that he might escape to a Free State. 'My, that's Abolitionist talk,' says Huck incredulously; 'being a slave is like having to wear shoes. You got to accept it whether you like it or not.' To this, Jim replies, 'Well, if God intended you to wear shoes, why weren't you born like that?' 'Well, that's what I mean,' responds Huck, 'you were born a slave, Jim … God intended you to be a slave.' At which point Miss Watson appears, shouting out that it's time for Huckleberry's Bible reading. God gives and God takes in strange ways, we might observe sardonically.

The film ends with Huckleberry and his confidant, the Widow Douglas, standing at the quayside. He waves goodbye to Jim, who is on his way to a Free State. To understand fully this scene, we need to return to the preceding one, where Huck reveals to the Widow Douglas that his recent experiences with Jim on the run, as it were, have made him re-think important beliefs: 'No human being has the right to own another human being . . . That's why I'm asking you please to let Jim go.'[9] Widow Douglas agrees, on the condition that Huckleberry go to school, wear shoes and stop smoking – he says 'yes', but does not keep his promise. In the concluding scene I touch on above, Huck is well dressed in black with a large hat, a waistcoat and, importantly, shoes. But as he brings his handkerchief to his nose, the stem of a pipe is seen. Then, turning around together with the Widow, and walking away, we see that he is now only wearing socks – he has left his shoes behind. The camera focuses on these rather forlorn objects, in much the same way that it had singled out Huck's naked right foot at the beginning of the film.

It is a left foot, however, that (obviously) is at the heart of *My Left Foot* (1989), directed by Jim Sheridan and starring Daniel Day-Lewis and Brenda Fricker, both of whom went on to win Oscars: Day-Lewis for Best Actor in a Leading Role, and Fricker for Best Actress in a Supporting Role.[10] Critically and popularly well received, *My Left Foot* was based on the book of the same name by Christy Brown (1932–1981), an Irish writer and painter who had cerebral palsy, could not walk or talk, and who only learnt to type with the toes of his left foot (illus. 38).

Like *The Adventures of Huckleberry Finn*, the film begins with a foot, but one now seen passing over a computer keyboard. It's an

38 Christy Brown (Daniel Day-Lewis), his bare foot playing with a record, in *My Left Foot* (dir. Jim Sheridan, 1989).

extreme close-up in which we can easily make out hairs and pronounced veins – visceral passage. Immersed, as it were, in deep darks and sharp lights, the foot and its mise en scène are reminiscent of paintings by Caravaggio, discussed in Chapter Three, with their detailed anatomy and their strong chiaroscuro. For one brief moment, the foot resembles a hand. It is shown trying to remove a vinyl record from its cover. It succeeds in doing this, but at the expense of its owner, whose anguished face we finally see from below, which is consistent, it seems to me, with (problematic) notions of the human erectus, touched on in my introduction: from the 'base' to the 'intellect' – a vertical progression, supposedly. A grand operatic song frames this opening sequence – 'Un'aura amorosa', from Mozart's *Così Fan Tutte*, a haunting song about 'the breath of love', hope and sustenance.

My Left Foot traces the afflicted Christy Brown from his birth into an Irish working-class family – a loving family, to be sure, but whose pig-headed father looks dismissively on his son until the moment (an epiphany, in effect, for him and his family) when Christy manages by way of his toes, and with a piece of chalk, to write the word 'mother' on the floor. He now can speak, as it were, with his left foot. He is about ten years of age. Changing familial perceptions of him, this action allows Christy to turn to painting as a hobby – with his toes, of course (illus. 39). He also becomes increasingly included in the capers of his neighbourhood's young, which involve, among other things, a football game.

The scenario is an alleyway: graffiti on the walls, washing hanging out to dry and criss-crossing the tenements, boys running around playing with the ball. Christy is the goalkeeper. A penalty ensues, and Christy's mates select him to take it (why exactly, I'm not sure). This leads to an uproar – 'You can't hold 'im up to take the kick!', shout the opposition. So one of his brothers lays him on

39 Christy Brown painting with his toes, in *My Left Foot* (1989).

40 The football scene, *My Left Foot* (1989).

the ground, and places the ball on the spot (illus. 42). A dramatic foreshortening has Christy's head almost falling out of the film's frame, and the brown ball is sitting there, isolated and forlorn. Christy strikes the ball with his left foot – goal!

There is an elementary quality to this scene: the shouting and the screaming of one side against the other; the win-or-lose dynamic, one tribe against the other; and then there is brotherhood and solidarity, and all this in the context of a young man who is acutely disabled (initially moved around in a pushcart until his devoted mother finds the money to buy him a wheelchair). Considered in these terms, the laying of Christy on the ground – before he kicks the ball – strikes me as a concise comment on how the human body is capable of effective thought and action in the 'horizontal', if I can put it that way. Here we are back in Huxley's privileging of Man's 'upright position' in his *Evidence as to Man's Place in Nature*, which, as we have seen, differentiates between hands and feet, the former considered to be 'instruments' of the rational, while the

latter are simply seen as 'integral to bipedal locomotion'. *My Left Foot* repudiates this, emphatically. Christy will go on to write his autobiography (1954) – with his left foot, of course – and he ends up marrying his long-term handler and nurse, Mary Carr (played by Ruth McCabe), in 1972; a Hollywood scenario, it would seem, but in actuality the relationship was marred by depression, alcoholism and neglect and perhaps abuse of Christy by Mary.[11] Christy Brown died at the age of 49 after choking on a meal of lamb chops.

FOOTLOOSE AND FANCY FREE

Rolling easily off the tongue, the expression 'footloose and fancy free' is all about a freedom to do what you like and when you like in the absence (supposedly, but not always) of romantic, family or professional responsibilities. Often associated with the (relatively) young, it suggests a lifestyle that is easy-going and peripatetic.[12] The films I discuss here fit this description but also move in other directions, from romantic narratives and furtive agendas to fantasies and fairy tales: an underlying sense of innocence, of joie de vivre, links them all.

This is nowhere more apparent than in *Roman Holiday* (dir. William Wyler, 1953), starring Audrey Hepburn as Ann, the Crown Princess of an unspecified country, and Gregory Peck as Joe Bradley, an American journalist covering the princess's European tours.[13] The princess visits London, Amsterdam, Paris and finally Rome, where we see her being introduced at a formal reception to various dignitaries. It is in this rarefied atmosphere that 'footloose',

as it were, makes its unexpected appearance. To quote directly from the script of *Roman Holiday*:

THE MAHARAJA [shaking Ann's hand]: Thank you, madame. [*The Master of Ceremonies announces the next couple, in German*].

ANN [*hidden beneath her dress, she takes her right foot out of its shoe and stretches it*]: Guten aben [sic].

MASTER OF CEREMONIES [*as Ann puts her foot back*]: Prince Istvan Barossy Nagyavaros.

ANN: How do you do? [*he kisses her hand*] . . .

ANN [*holding the woman's hand as she curtsies*]: Guten aben [sic].

41 Ann (Audrey Hepburn) takes her right foot out of her shoe, in *Roman Holiday* (dir. William Wyler, 1953).

42 Ann's solitary shoe, *Roman Holiday* (1953).

. . .

[The Master of Ceremonies announces the next couple. As she greets them, Ann rubs her tired right foot against her leg (illus. 41)]

. . .

COUNT *[kissing her hand]*: Good evening. *[Suddenly, Princess Ann loses her balance as her foot slips over her shoe, knocking it over. The Count's eyeglass pops out in surprise and he smiles back as he regathers herself]*

. . .

[The Master of Ceremonies announces the next guest as Ann pushes her shoe again in an effort to right it]

. . .

[*The Ambassador then motions her to sit down. As she sits back into the chair with the Ambassador and the Countess on either side her dress pulls back, revealing the shoe (illus. 42). The orchestra starts playing a waltz. Ann tries as inconspicuously as possible to drag her shoe back with her foot . . . The Princess stirs in her seat trying to get her shoe back, fiddling with her gloves as cover. A man standing behind the Ambassador motions to him and he shrugs and gets up, bowing and presenting his arm to the Princess. The Princess rises and, pausing for time to regather her shoe, is led onto the ballroom floor by the Ambassador. Taking her up to dance he looks at the area in front of the seat and, relieved that the shoe isn't to be seen, continues dancing with her as the other guests watch.*][14]

Taking place very early on in the film, this amusing and charming scene sets the tone for *Roman Holiday*: a young princess who would love to escape the demanding responsibilities of her role, even briefly, so that she can enjoy the pleasures of Rome. This she does, incognito. Shortly after discovering the princess's true identity, Joe Bradley ingratiates himself with her. Unexpectedly, they fall in love. Nothing could come of this, of course, but Bradley in the end does not use the photographs he had taken surreptitiously of the princess in her many joyful escapades. Their publication, he recognizes, would have untold and very possibly harmful consequences for her.

The Cinderella-like quality in *Roman Holiday* is hard to resist: the stockinged feet and shoe sequence I have just described in detail. But, unlike Cinderella's story, there is no fairy-tale ending. Princess

Ann and Joe Bradley go their separate ways, while Cinderella, a young, kind woman who had suffered at the hands of her cruel stepmother, ends up marrying Prince Charming – both of them living 'happily ever after'. To go back to the beginning, however, and then in summary, Cinderella attends a courtly ball, aided by her Fairy Godmother, but if she does not leave before midnight, the Godmother tells her, she will return to her simple self. At the ball (as we know), Cinderella meets and falls keenly in love with the Prince, a sentiment that is reciprocal. With midnight drawing ever so close, Cinderella rushes off to her coach (provided by her Fairy Godmother). In the process, however, she leaves behind one of her glass slippers. The story concludes with the Prince searching out the 'foot' that will fit the 'shoe'. And when it does, it is Cinderella, and voila.

The story of Cinderella is habitually associated with the hugely popular Walt Disney movie of the same name from 1950. Indeed, this film is often seen as synonymous with Cinderella: Cinderella *is* Disney and vice-versa. The fable, however, has a far more nuanced and lengthy history, going back to the French writer Charles Perrault, whose 'Cinderella, or The Little Glass Slipper' was published in Paris in 1697, in *Histoire ou contes du temps passé*, a collection of fairy tales. Much further back, Tuan Ch'eng wrote a similar tale during the reign of the Tang dynasty (CE 618–907). And there are many other pre-modern examples, too.[15]

I have skirted around Cinderella and her ubiquitous 'glass slipper', an object I suspect is now even more firmly embedded in the popular imagination thanks to Kenneth Branagh's recent and hugely successful *Cinderella* (2015), starring the English actress

43 The glass slipper of Cinderella (Lily James) in Kenneth Branagh's *Cinderella* (2015).

Lily James (of the TV series *Downtown Abbey* fame) as a wonderful, unworldly but thoroughly winning Cinderella. Her 'glass slipper' (illus. 43), incidentally, was actually made from Swarovski crystals, heavily faceted and heavy to hold, and was even made available in a limited edition of 400: 'expertly crafted with 221 facets in clear crystal this 85-percent scale replica of the movie slipper features an exquisite rhodium-plated butterfly, set with light blue crystals.'[16]

Involving both longing and obsession, *The Barefoot Contessa* (1954) – produced, directed and written by Joseph L. Mankiewicz – was a modern-day fairy tale masquerading as a drama (illus. 44).[17] Told with flashback recollections, it is a convincing film with affecting performances, described by the eminent movie director François Truffaut as 'A subtle and intelligent film, beautifully directed and acted.'[18]

Echoing *Roman Holiday* in parts, Mankiewicz's film ends, in contrast, on a shocking note: the heroine, Maria Vargas (played by Ava Gardner), and her 'lover' (now *that* is another story which I touch on below), are killed by her husband, Count Vincenzo Toriato-Favrini (played by Rossano Brazzi). Their marriage takes place at the height of Maria's career as a movie star, a career largely nurtured by the worldly but kind writer and film director Harry Dawes, played by Humphrey Bogart. Dawes, accompanied by Kirk Edwards (played by Warren Stevens) – a thoroughly disagreeable movie mogul – and his obnoxious publicist Edmond O'Brien (played by Oscar Muldoon) had earlier made a special trip to 'a not very fashionable nightclub in Madrid' (Dawes's description) to see Vargas dance (her talents and her 'looks' were well known).

44 Poster for *The Barefoot Contessa*, dir. Joseph L. Mankiewicz (1954).

Specifically, they went to offer her a contract in Edwards's movie – an offer she couldn't refuse, or so he thought. But she does refuse, and it is left to Dawes's sympathetic intervention to persuade her otherwise.

So Vargas ends up in Los Angeles, where she has three successive and successful films. Her rise to fame belies the unassuming make-up of an unpretentious woman who went around shoeless in her hometown in Madrid, and who was born and raised in a milieu so totally different to the one she was now experiencing in Los Angeles. 'I feel safe with my feet in the dirt,' Vargas says to Dawes, in terms that seem to recall Huckleberry Finn's own penchant for going about barefoot. Yet going barefoot has an altogether different significance in this context: Vargas's penchant is all about her sense of self as a Spaniard first and foremost, and someone, as we shall see, for whom being shoeless is part of the narrative of her early life.

Vargas's naked feet are first seen very early on in *The Barefoot Contessa* in ways that are unapologetically erotic. We are in a

45 Barefoot Contessa, in *The Barefoot Contessa* (1954).

Madrid nightclub where Vargas is reluctant to dance – she's already performed once, and is not prepared to do so again, much to the irritation of Mr Edwards. Dawes eventually goes looking for her, ending up at Vargas's dressing room. He knocks at the door, receives no reply, but still lets himself in. There, behind a curtain, he sees Vargas's bare feet, but also those of a man with his shoes on. Dawes picks up Vargas's shoes from the floor and drops them on a stool. They make a noise, and we see (perhaps as a result of this sound, perhaps not) Vargas's left big toe rise as her toes clench – it is a very sexy scene (illus. 45). 'Signorina,' says Dawes, 'your bare feet are showing.'

What then follows is a combative but knowing encounter between Dawes and Vargas, during which her so-called 'cousin', the man with her behind the curtain, leaves the room through a window in a way that borders on the comedic. Of course, he is Vargas's lover. Dawes persuades her to come to meet Mr Edwards, but makes it clear that he sees him as an intolerable magnate. Leaving her dressing room, Vargas is barefoot. She returns and puts on her shoes and, after second thoughts, a black shawl – she is not going to allow her sexuality to mediate between her and Edwards. Their meeting, however, is a disaster – she excuses herself, apparently to make a telephone call, but does not return, so Mr Edwards instructs Dawes to find her and 'bring her back'.

Dawes is conflicted between his distaste for Edwards and his own complicit self, but is clearly sympathetic to Vargas whom he sees as a decent person and potential 'star'. Encountering Vargas at her home, he meets her demonstrative mother in passing, her invalided father and her level-headed brother. Joining Dawes

outside, Vargas speaks in very personal ways about her early history – a narrative in which the 'foot' features in ways that help frame the remainder of the movie. These reflections stand in sharp contrast to the scene in Vargas's dressing room, where, as we have seen, her naked feet and sexuality go hand in hand, and her remarks are vacuous. They are not vacuous in this scene: 'When I was a little girl, with so many others,' Vargas says to Dawes,

> there was no money to buy shoes for me. And when the bombs came in the Civil War, I used to bury myself in the dirt of the ruins to be safe. I would lie there safe in the dirt, and wriggle my toes . . . and dream of someday being a fine lady.

And later, she says, 'I hate shoes, Mr Dawes. I wear them to dance and to show myself. But I feel afraid of shoes, and I feel safe with my feet in the dirt.'

Vargas, however, does end up in Los Angeles, where she becomes a 'star'. Dawes – mentor, father figure and unconsummated lover – is never far behind. In one scene, though, she admits to him that she is unhappy and feels she should go home to Madrid, to 'where I belong . . . in the dirt of the streets'. Yet 'belonging', Vargas quickly acknowledges, is elusive. Dawes asks if she has she been 'unhappy' in Los Angeles, to which she replies, 'In many ways it's been beyond my dreams. Like a fairy tale of this century, and I have been *la cenicienta*' (Spanish for Cinderella). But she quickly concedes that she has failed to mention the prince who looks everywhere for the heroine so that 'he can put the shoe back on her foot'. An ambiguous

concession, but one that points to Vargas's (potential) prince who, in fact, is nothing more than a Latin American playboy, Alberto Bravano (played by Marius Goring), whom Dawes finds 'mean' and 'dirty' and over whom he and Vargas clash. It is not Bravano, however, that Vargas finally falls in love with, but Count Vincenzo Torlato-Favrin, played by the handsome and suave Rossano Brazzi, someone who comes much closer in reality to Vargas's/Cinderella's prince. As it turns out, he is impotent, having been injured in war, so Vargas chooses to get pregnant by a 'lover', about whom she plans to tell her husband, hoping that he will be sympathetic – but, suspecting the relationship, Rossano shoots them both. It is a simple but histrionic ending, one that brings to a devastating con-clusion a film about Hollywood, its tropes and its shabby side; a film about star-making which actually involves (cunningly) a star-in-the-making (Gardner); and a film about love and desire and their often conflicting and frightening dimensions. And then, finally, there's the statue that we first encounter at Vargas's funeral, which introduced *The Barefoot Contessa*; the sculpture shows the glamorous Vargas in a quasi-classical pose, with her left bare foot appearing from beneath her elegant gown. Fast-forward to the end of the film, at which we revisit the funeral and come across the statue again: this time, however, it is seen from behind, in all its steely whiteness, but only from the waist up: the foot is not visible, and the future is bleak. In a wet overcoat, Dawes walks away slowly, Western-like, towards an imaginary horizon.[19]

There is no such melancholy in *Barefoot in the Park* (1967), a romantic comedy directed by Gene Saks and written by Neil Simon, whose play of the same name premiered on Broadway in

46 Paul Bratter (Robert Redford) in *Barefoot in the Park* (dir. Gene Saks, 1967).

1963.[20] *Barefoot in the Park* is an uncomplicated film about the ups and downs of a newly married, young conservative attorney named Paul Bratter (played by Robert Redford) and his vivacious, fun-loving wife, Corie (played by Jane Fonda). Corie's mother, Ethel Banks (played by the indomitable Mildred Natwick), is a mother-in-law of some presence who falls in love with Victor Velasco (played by Charles Boyer), an elderly roué who lives in the same apartment building as the Bratters.

So much for the general story. As to the movie's title, *Barefoot in the Park*, its context is straightforward. Increasingly irritated by her husband's cautiousness, Corie taunts him by saying that he would never run barefoot with her in the park. When, in fact, he does run barefoot in the park (by himself, however), this is towards the end of the film. He has run away from home and ended up drunk and agreeably disorderly in Washington Square Park, New York (illus. 46). It is here that Corie finds him. Dressed in a grey suit with an open-necked white shirt and a dangling tie, the shoeless and

47 Corie Bratter (Jane Fonda) embracing Paul Bratter in *Barefoot in the Park* (1967).

inebriated Paul is the antithesis of his earlier self. The appearance of this out-of-self character, however, leads – unsurprisingly – to a rapprochement between husband and wife.

There is more to bare feet in this film, though. Early on, in what I think is the film's most comic – and witty – scene, Corie and Paul have to part company, having spent five days honeymooning in a hotel. It is clear that their sexual activities have been prodigious.

Saying goodbye to her husband, who insists that he must finally go back to work – he is, after all, an up-and-coming attorney – there is Corie in a revealing blue pyjama top (we soon learn it is her husband's) and nothing else, kissing him ardently just outside their door (illus. 47). Disengaging himself from this *moment de passion*, Paul quickly moves to the elevator (illus. 48). In a neat bit of editing, we see Fonda, barefooted and seductive, sidling towards the elevator just as its door opens; Paul enters the elevator, becoming surrounded by men and women who seem eminently mature and sensible. They are gobsmacked by what they see and hear: Fonda, looking at a tired Redford and saying, cheekily – and to his evident dismay and our amusement – 'Thank you, Mr Dooley. Next time you're in New York, just call me up.' This is a wonderful parody of a call girl that makes much of Fonda's lithe legs and bare feet. In contrast, Paul Bratter's running shoeless and barefoot in lower Manhattan is all about rupturing middle-class conventionality.

Also set (largely) in lower Manhattan, *The Butcher's Wife* (dir. Terry Hughes, 1991) – described by that abundant American film critic Roger Ebert (1942–2013) as a film that 'wants to be a whimsical, heart-warming fantasy, and it almost succeeds' – is about Alex Tremor (played by Jeff Daniels), a local psychiatrist who ends up in love with the film's central character, the southern state clairvoyant named Marina (played by Demi Moore).[21] Daniels is toady, while Moore is beguiling. Having said that, I find the film variously quirky and tender. And underpinning it all are Marina's feet, from an introductory sequence in which we see her barefoot on some island off the southern USA, to her uprooting to go and live with her husband (whom she found on the island, of all places!),

48 Corie Bratter following Paul Bratter to the elevator in *Barefoot in the Park* (1967).

an affable character by the name of Leo Lemke (played by George Dzundza), who is a butcher from Greenwich Village.

The Butcher's Wife's (implicit) claims to the genre of fairy tale are announced as its opening credits roll, and we see a little girl standing at the top of a towering lighthouse and looking out at the vast sea. The voice-over (Demi Moore's) says,

> Over the water and across the sea, on a little island off the Carolinas, there once lived a young girl with a great gift who thought she knew it all. That's me. Folks call me Marina and I'm a clairvoyant.

She believes that a string of magical signs, including a ring she found in an oyster, have sent her husband to her; before she/we know it, she's head over heels for her 'Adonis, my Poseidon, no my Zeus'. He is literally washed ashore, on his fishing boat. And so,

the portly, affable Lemke and Marina get married, and soon they leave for New York, where our first real sight of Marina is her naked feet as she steps out of Lemke's car onto the wet, glistening tarmac of Greenwich Village (illus. 49). And it is these feet that continue to step through some of the film's unfolding narratives. There is Marina working with bare feet in Lemke's butcher shop, testimony to her independence but also a whacky take on meat, bodies and hygiene (illus. 50 and 51). Then there is the more revealing scene in which Marina, exasperated by Lemke's outburst in a telephone conversation, leaves the shop and winds her way to a boutique selling upmarket clothes and shoes. On entering, its haughty female manager sees her bare feet and dirty white apron;

49 The naked feet of Marina (Demi Moore), in *The Butcher's Wife* (dir. Terry Hughes, 1991).

50 Marina in front of the butcher's shop, with Dr Alex Tremor (Jeff Daniels), in *The Butcher's Wife* (1991).

recoiling, she says, 'I don't think I've ever seen you here before.' In walks another woman, evidently insecure, who says she's looking for something 'dowdy and plain' to wear at a church recital. Segue to Marina – we see her seated, dusting her dirty soles and trying on shoes (illus. 52), gleaming white with pearls and bows, which

51 Marina cutting meat in the butcher's shop, in *The Butcher's Wife* (1991).

52 Marina trying on shoes, in *The Butcher's Wife* (1991).

can best be described as ornate. The shoes do not fit, but she buys them nonetheless, and out she walks proudly – but not before she has persuaded the prim-and-proper woman in the shop, Stella Kefauver (played by Mary Steenburgen), to buy a slinky dress. We later learn that Stella has always wanted to be a nightclub singer, and Marina suggests (correctly – she is a clairvoyant, after all) that she will one day wear the dress while singing in a nightclub. A scene shortly after has Marina going out alone in the evening wearing her new shoes. She ends up with two friends, elderly women who seem to spend most of their time sitting outside on the street in collapsible chairs. The camera draws back to reveal, amusingly, the three of them and their shoes: the woman on (our) left in white, throwaway slippers; Marina in the middle with her fancy shoes; and the other woman in what seems to be silver-coloured shoes or slip-ons (it is not clear). We never see Marina wearing her shoes again, nor do we see her bare feet, with one

exception – understandably, when she makes love to Tremor in her apartment for the first time. But the shifting focus – literally and figuratively about halfway through the movie – from Marina's feet to other themes suggests a move from the feral childlike woman (in some ways, like the gamin in *Modern Times*) to someone who is trying to reimagine herself in a new world.

To conclude 'Footloose and Fancy Free' with something of quite a different order, I turn to *Avatar: The Last Airbender*, a highly successful American TV series (directed, variously, by Lauren McMullan, Dave Filoni, Giancarlo Volpi et al.) that appeared on Nickelodeon in the years 2005–8. A mixture of Japanese anime and Walt Disney cartoon-like representation, this animated series is set in a quasi-Asiatic milieu in which mythical stories play out in witty ways that go, I think, well beyond the series' demographics of children between six and eleven years old. There are smacks of Orientalism here, certainly, but these are more often than not subverted in droll and tongue-in-cheek ways.

Take, for example, an episode from *Book Two: Earth, Volume Three*, 'The Tales of Ba Sing Se', written by Joann Estoesta and Lisa Wahlander, in which feet are foremost.[22] Toph Beifong (the only character in *Avatar* to have a surname) is an 'earthbending' master who, blind since birth, goes on to discover 'metalbending'. In this tale, we find Toph in bed lying spread-eagled on her stomach, barefoot and with her massive spiky black hair fanning out in all directions. Katara, a master of 'waterbending', enters and wakes up Toph abruptly, asking if she's 'going to get ready for the day', followed by, 'You're not going to wash up? You've got a little dirt on you – everywhere, actually.' To this, Toph replies, confidently,

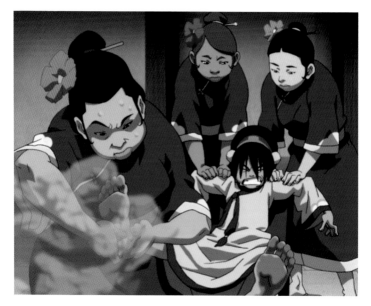

53 'The Tales of Ba Sing Se', from *Avatar: The Last Airbender*, TV series, 2005–8.

'You call it dirt, I call it a healthy coating of earth.' There's something of Huck Finn about Toph, and maybe even of Chaplin's gamin – an irreverent independence. Deciding that they need a 'girls' day out', Katara takes her friend to the Fancy Ladies' Day Spa. Head lowered and barefoot, Toph is under-whelmed, saying, tongue-in-cheek, it 'sounds like my kind of place', to which Katara responds, 'Are you ready for some serious pampering?' 'Sure . . . as long as they don't touch my feet,' says Toph. But touch her feet they do: scraping her right sole vigorously (illus. 53), as Toph screams in anguish. The masseuse's activity results in an unexplained 'explosion' that sends the masseuse crashing through a wall with debris flying all over. This little story

ends with Toph, aided by Katara, getting even with three girls who mocked Toph's make-up soon after leaving the spa. Exercising her 'earthbending' skills, Toph creates a hole in the bridge on which the girls stand. Falling, gobsmacked, through the hole, the girls are swept away by a huge wave fashioned by Katara. 'One of the good things about being blind is that I don't have to waste my time worrying about appearances,' Toph says; 'I know who I am.' This funny but poignant tale gives a whole new meaning, I would suggest, to the expression 'finding your feet'. Toph indeed has found her feet, in more ways than one.

JUMPING IN WITH BOTH FEET

Film cognoscenti will be well aware that the American director Quentin Tarantino, still *enfant terrible* of current film-making, is a self-confessed foot fetishist. At the New York Friar's Club Roast at the Hilton Hotel in 2010, his close friend and muse – as he describes her – actress Uma Thurman (b. 1970) celebrated the occasion by joining Tarantino in drinking champagne out of her striking red-soled Christian Louboutin shoes.[23] Photographs show a delighted Thurman in a sheer black T-shirt and a broadly smiling black-jacketed Tarantino. A journalist, Leon Markovitz, more recently 'measured' the number of times the female bare foot appears in Tarantino's films.[24] Though they do not appear in his recent *The Hateful Eight* (2015) or in his debut *Reservoir Dogs* (1992), and they are only hinted at in *Django Unchained* (2013), female bare feet feature in all of his other eight films. In *Pulp Fiction*, the bare feet are substantial; in *Jackie Brown*, less so; in *Kill Bill: Volume 1*,

they are ubiquitous, while in *Kill Bill: Volume 2*, they are there but not pervasive; in *Inglourious Basterds*, finally, bare female feet leave their distinctive mark.

Tarantino's female foot fetish manifests in ways that slither between desire and repulsion, between objectification and a more graded empowering, as it were, of the object – the foot – itself. In important respects, it seems to me, we are dealing with the notion of the 'uncanny', which many art and cultural historians have correctly observed in Surrealism.[25] It is Freud's understanding of the 'uncanny' – as articulated in his essay of the same name (1919) – that gave currency to this term, at its most basic. It is about the coming-together of the familiar and the foreign in ways that lead to a sense of discomfort, of dislocation: Freud writes, 'the "uncanny" is that class of the terrifying which leads back to something long known to us, once very familiar'.[26] There is more to the 'uncanny' than this: Freud will go on to talk about the Prussian writer and composer E.T.A. Hoffmann, whose *The Sandman* (1817) was popularized in Jacques Offenbach's *Les Contes d'Hoffmann* (Tales of Hoffmann), an *opéra fantastique* which was first performed in Paris in 1881. In particular, Freud picks on the 'double' in *The Sandman*, the doll, named Olympia. Citing the Austrian psychoanalyst and writer Otto Rank (1884–1939), one of his closest colleagues – whose book *Der Doppelganger* (The Double) was published in 1925 although written some ten years earlier – Freud writes about how the 'double' involves, inter alia, the mirror and its reflections (of self), a belief in the soul and a fear of death.[27] Freud goes on to argue that such ideas 'have sprung from the soil of unbounded, self-love, from the primary narcissism which holds sway in the

mind of the child.'[28] And he concludes, provocatively, by saying, 'From having been an assurance of immortality, he [the 'double'] becomes the ghastly harbinger of death.'[29] So we have an 'uncanny' that brings together the frighteningly familiar, the premonition of death and a vein of narcissism, all of which, it seems to me, run through Tarantino's films, in which the narcissistic is both a narrative in the films and also, by extension, a comment on Tarantino himself.

I begin with Tarantino's *Kill Bill: Volume 1*.[30] The widely known and respected film critic whom I've quoted before, Roger Ebert, who wrote for the *Chicago Sun-Times* from 1967 to 2013, gave it four out of four stars:

> *Kill Bill: Volume 1* shows Quentin Tarantino so effortlessly and brilliantly in command of his technique that he reminds me of a virtuoso violinist racing through 'Flight of the Bumble Bee' – or maybe an accordion prodigy setting a speed record for 'Lady of Spain'. I mean that as a sincere compliment. The movie is not about anything at all except the skill and humor of its making. It's kind of brilliant.[31]

Leaving aside Ebert's ornamental analogy, he is right in one respect: the film is 'not about anything at all except the skill and humor of its making' – to which one must add, of course, the violence that is intensely choreographed (remarkably so) and which manifests itself in all three of Tarantino's films that I discuss here, and others as well. Heavily indebted to martial arts films, a subgenre of action films, *Kill Bill: Volume 1* also salutes anime (here made by a Japanese

anime studio, *Production I. G.*), as well as using black-and-white film and slow motion. Tarantino's scavenging of genres – a perfectly proper postmodern tactic – takes 'revenge' as its *raison d'être* and modus operandi. (I wonder: is some notion of 'revenge' at the heart of the postmodern?) Stunning editing involving thrusts; cuts; loss of limbs; blasts of blood, cartoon-like, from arms and legs; and heads cut off, constitute an approximately seventeen-minute sequence towards the end of the film, in which the movie's protagonist, The Bride (played by Uma Thurman), known widely as a killer *par excellence*, takes on the seemingly never-ending army (the Yakuza) of O-Ren Ishii (played by Lucy Liu), a former member of 'The Deadly Viper Assassination Squad' (DVAS) to which The Bride had once belonged.

To understand this carnage that takes place in a restaurant in Tokyo, we need to go back to the black-and-white opening scene (before the credits roll), in which The Bride, her husband and friends, are massacred by Bill (her one-time lover) and four colleagues, all of whom belong to the DVAS. (Actually, as we are told in *Kill Bill: Volume 2*, the wedding is, in fact, a rehearsal, a nice conceit.) In her (supposed) dying throes, she tells Bill – we only see his boots – that her child-to-be is actually his. The Bride, we later discover, survived and has been hospitalized in a coma for four years.

When we see her, she is lying seemingly 'etherised on the table' (apologies to T. S. Eliot, 'The Love Song of J. Alfred Prufrock', 1920). In walks an orderly in a standard blue uniform accompanied by a baseball-hatted lout. What follows is an unexpected scene, a nasty scene – each time I look at it, and as I write, I wish it had been

omitted or, at any rate, rephrased. The Bride, as we know, had been shot but has survived. Tarantino shows the lout handing over $75 to the slimy orderly to 'fuck' the torpid woman. (She is not torpid. A mosquito had earlier bitten her and she had awakened suddenly. A remarkable close-up of this is all about skin and pores; it is a visceral moment typical of Tarantino's penchant for the haptic. On hearing people approaching, The Bride immediately falls back on her bed – comically, it should be said.) The orderly gives instructions as to how she may be 'fucked'– no bruises, no bites – and, saying that her 'pooch' may be 'dusty', he gives the rapist-to-be a jar of Vaseline to help insertion. It is a dirty, partly broken jar – a simple, tawdry motif that sums up the nastiness of the incident. The lout mounts The Bride, thinking that in her comatose state she must be 'available' – not so. As he moves on top of her, she bites his bottom lip and pulls it out in a shocking scene that results in his bloodied death. (Why this should lead to such an alarming death, I'm not sure, but then this is Tarantino.)

Getting out of her bed with difficulty – she cannot use her legs after years lying inert – The Bride falls on the floor. From some-where, she finds a spring knife and, with it, she crawls to an area just behind the door of the room. The orderly enters, cock-a-hoop, and she slashes his ankle. What follows is a brutal attack – The Bride smashing the orderly's head with the door time and again. She calls out, 'Where's Bill?', and he says he has never heard of him. Then seeing his nametag, 'Buck', and the word 'fuck' tattooed on his hand, she recalls him coming into her hospital room and announcing, 'My name's Buck, and I've come to fuck.' She kills him; in the process, we see her thighs, legs and soles in a gentle, seductive

54 The Bride (Uma Thurman), in *Kill Bill: Volume 1*
(dir. Quentin Tarantino, 2003).

light, vividly contrasting with the foreshortened blue trousers of
Buck and his booted feet that almost project out of the film's frame.

Dressing herself in his clothing, The Bride takes Buck's car keys
and wheels herself to the underground car park where she locates
his vehicle (illus. 54). Gaudy – appropriately – in its sharp yellow
exterior, pink signage and red upholstery, it is called 'Pussy Wagon'.
Struggling to pull herself into the car – after all, she still is unable
to use her legs – Thurman's slightly out-of-focus naked soles look
us in the face, briefly, and then for a slightly longer period, by which

55 Traumatised, The Bride lying in the 'Pussy Wagon' in *Kill Bill: Volume 1* (2003).

56 The Bride's feet in *Kill Bill: Volume 1* (2003).

time she is lying prostrate on the car's front two seats (illus. 55). The point of view shifts, and we see her feet now in sharp focus, her veins visible, a bunion (perhaps) and her second toe larger than her big toe (illus. 56). Shifts in points of view follow, once, twice: back to the soles, beyond which we see her massaging her right thigh, and then back to her feet seen from her perspective. All this is a prelude to what will become one of the defining images of Tarantino's obsession with the naked female foot – a close-up of The Bride's feet, in which the (conventional male) gaze intriguingly transfers itself into the object of the female (subject's) gaze: she looks intently at her feet, saying 'Wiggle your big toe,' not once or twice but six times. As she says this, the camera moves closer and closer to her feet. This is all about (female) empowerment, staged (incongruously) in childlike terms – the *wiggling* of the big toe; an exercise which is the antithesis to Bataille's meditations on the miserableness of the big toe, discussed in that eponymous essay.

Like its precursor, *Kill Bill: Volume 2* also begins with a black-and-white sequence that revisits the massacre at The Bride's wedding, which we are now told took place at a small chapel in El Paso,

Texas.[32] For the first time, we see Bill, who, arriving unexpectedly, enters into an anxious but delicate face-to-face with The Bride. She walks towards him, bare feet in sandals, while Bill, recalling the opening passage in *Kill Bill: Volume 1*, steps slowly towards her in his boots. It is like an encounter between gun-slinging cowboys, which we know will end in a shooting. To cut to the quick, which is never easy with Tarantino's convoluted scripts, in *Kill Bill: Volume 2*, The Bride sets out to kill Bill, her primary target; his brother Budd (played by Michael Madsen) and the one-eyed Elle Driver (played by Daryl Hannah), both DVAS assassins involved in the 'marriage massacre' in *Kill Bill: Volume 1*, are also on her hit list. Bill lets Budd know that The Bride is out to get him: anticipating this, he ambushes her when she arrives at his trailer and shoots her with rock salt. After being buried alive by Budd – he wants her to suffer, to really suffer – she manages to cut and scrape her way out of the coffin. Resurrection in one form or the other blesses The Bride (think back to her sudden awakening after four years in a coma). Elle Driver later kills Budd, whom she apparently disliked for a long time (no love lost with these assassins); more specifically, she had gone to his trailer to give him one million dollars for The Bride's special samurai sword named Hanzo, after the real Hattori Hanzo, a famous sixteenth-century samurai warrior. The context is this: The Bride, née Beatrix Kiddo (her 'real' name emerges in *Kill Bill: Volume 2*), had once gone to study under Pai Mei (played by Gordon Liu) in Japan, a racist and misogynist at heart but also a consummate martial arts master – and the world's finest sword-smith. Beatrix's one-time lover Bill and Elle Driver had also studied under Pai Mei; Elle, who had once insulted Mei, and had her right

eye plucked out by him in a fit of pique, would go on to kill the martial master, saying that he was a 'miserable, old fool'. From Mei, Beatrix had acquired a very special (samurai) Hanzo sword – as indeed had Bill, sometime earlier. Bill gave this sword to his brother, Budd, who, contrary to what he had said to Elle (that he had sold it), had in fact hidden it in his trailer. This tortuous narrative sets the scene for the remarkable battle – and battle it is – that takes place in Budd's trailer between Beatrix and Elle. As we will see, Tarantino's fascination with the female foot is in your face in more ways than one.

Let me explain. Elle has just killed Budd with a Black Mamba snake secreted in the bag containing the money she was going to hand over to Budd for the sword. (Beatrix was codenamed Black Mamba when she was in the Deadly Vipers.) As Elle leaves Budd's trailer, the door opens and in fly, literally, the naked feet of Beatrix, which we see from her point of view; it is a stunning, Baroque-like spectacle. What ensues is an extraordinary and – yes – thrilling fight between these two women, both equally accomplished in the art of killing. The scene is one of cutting and thrusting, blow after blow, falling and cursing, and near-death experiences, with Beatrix and Elle going as far as they can, no holds barred. The Bride's bloody feet appear here and there in contrast to the black-heeled, pointed shoes of Elle. When the denouement arrives, however, kicks, fists and an assortment of 'things' give way to rapiers, the great Hanzo swords made by Pai Mei. (Elle, as we know, already had one, and Beatrix now discovers Bill's, which, years ago, he had given to Budd, with the inscription 'The Only Man I Ever Loved'. Facing off, with Beatrix telling Elle that Budd had obviously lied about 'selling' his

Hanzo, the two clash swords. But the death of Elle comes from (perhaps) an unexpected source – Beatrix dramatically pulls out Elle's remaining left eye, resulting in Elle writhing uncontrollably on the floor of the bathroom where earlier clashes had left it violated, as it were: magazines scattered all over the place, bloodied toilet roll, towels, broken surfaces, dismal toilet bowl. This is nothing less than a site of abjection, as Bataille would understand the term. There is more. Looking down at the miserable, howling figure of Elle, a truly horrible scene, Beatrix drops her (Elle's) eye on the floor – it seems to look at us for a second – and then she stands on it with her right bare foot, squashing it between her big toe and her 'long' or 'pointer' toe. Blood oozes out, outrageously. It is a dirty, soiled foot, behind which we can make out her other foot, covered in blood (illus. 58). Leaving this scene of unbridled horror, Beatrix, barefoot, walks slowly past the Black Mamba, which raises its head and hisses in her direction, almost comically (illus. 57).

The visual and the haptic, sight and touch: these senses come together in *Kill Bill: Volume 2*. Elle Driver's loss of one eye at the

57 The Bride running past a Black Mamba snake, its head raised as if to strike, in *Kill Bill: Volume 2* (dir. Quentin Tarantino, 2004).

58 The Bride stepping on Elle Driver's eye in *Kill Bill: Volume 2* (2004).

hands, literally, of Pai Mei, and then her loss of the other, this time at the hands of Beatrix, are critical moments in the film. The crushing of Elle's eye, a moment after Beatrix has dropped it on the floor, from whence it seems to look out at us – to 'face' us, as the art historian and critic Michael Fried would have it – is an instance of sight, touch and feet fully coming together literally and figuratively.[33]

Bataille's meditations, as I have suggested, are never far behind Tarantino. His *L'Histoire de l'oeil* (Story of the Eye) is an astonishing novella about the increasingly aberrant sexual activities between two teenage lovers; even read by today's behaviour, its overwhelming details of sexual encounters boggle the mind and concentrate it in ways both fascinating and mightily unsettling. We are dealing here with sexual encounters that know no bounds; they are all about a sexuality that stretches and breaks the so-called 'acceptable'. We are in the empire of the abject, if I can put it that way.[34] Suffice it to say that in section ten, titled 'Granero's Eye' (Granero is a champion matador), the narrator (unnamed, first person) is in the

company of Simone (his long-term partner) and the voyeur, Sir Edmund, all three at a bullfight in Madrid. The narrator, incidentally – and we learn this in the first line of *Story of the Eye* – was 'afraid of anything sexual'.[35] This would soon change, dramatically. The clash between matador and bull (and the latter's death), as described by the narrator, is electrifyingly sexual; it results in him and Simone having sex in a 'stinking shithouse' that is described in alarmingly vivid, misogynistic terms.[36] Arriving back in their seats, there is this reeling passage: 'raw balls' of the murdered bull arrive bizarrely on a plate before Simone (by permission of Sir Edmund). To contextualize this, Simone had apparently earlier expressed a desire to be served 'raw' the 'balls' of the first dead bull on a plate. What follows is equally shocking: Simone devours one of the testicles, and then, 'uncovering her long white thighs up to her moist vulva', she 'slowly and surely fitted the second pale globule.'[37] At this point, a bull kills the great bullfighter Granero, 'one horn plunged into the right eye and through the head.'[38] Simultaneously, Simone has an orgasm, while Granero's body is hauled away, his 'right eye dangling from the head'.

Elle Driver, as we know, lost one eye to Pai Mei, and the other to Beatrix – and both in horrific ways. I'm certainly not trying to establish a Bataille ('Granero's Eye')/Tarantino (*Kill Bill: Volume 2*) causal relationship here. What I am suggesting is a way of thinking and representing that is shared, it seems to me, by both the French academic and the American film-maker – an aesthetic, as it were, that engages with flesh and blood and sight, that explores intense sexuality which on one hand empowers women, but on the other is, I think, reductive.[39] Beatrix and Elle, after all, are killers; and

Simone, who at the end of *Story of the Eye* seduces, rapes and murders a priest, is, as Ladelle McWhorter remarks, 'no victim; rather she victimizes, and most of her victims are male'.[40]

I conclude this chapter and my musings on Tarantino with his *Inglourious Basterds*, released in 2009.[41] I should say that Eli Roth, who plays the notorious killer Donny 'The Bear' in the film, in fact, directed the film-within-the film, *Stoltz der Nation* (Nation's Pride), a Nazi propaganda film, under the pseudonym Laois von Eichberg. That *Inglourious Basterds* navigates hugely contentious issues is, of course, well known. Drawing on a (fictive) narrative of an American squad especially trained to murder Germans (as in *Kill Bill: Volumes 1* and *2*, revenge is a key ingredient), it includes ornate violence, anti-Semitism and racial stereotyping. My concern, though, is of course with feet. And Tarantino does not disappoint.

The scene in question has the Nazi colonel, Hans Landa, played by Christoph Waltz (who went on to win an Academy Award for Best Actor in a Supporting Role), in what at first seems to be an innocuous private meeting with Bridget von Hammersmark (played by Diane Kruger) (illus. 59). Landa is charming but unquestionably devious and malevolent, and proudly accepts the epithet 'Jew Hunter'. His guest is a hugely popular German film star who, in fact, is an undercover agent working for the Allies. She had earlier been involved in a deadly shooting in a tavern, 'La Louisiane', during which three Basterds were killed, along with a number of German military and civilians, but she miraculously survived. When First Lieutenant Aldo Raine (played by Brad Pitt), head of the team of Basterds, arrives at the carnage, she tells him that Hitler himself will be attending the premiere of the film *Stoltz der Nation*.

59 Hans Landa (Christoph Waltz) and Bridget von Hammersmark (Diane Kruger), in *Inglourious Basterds* (dir. Quentin Tarantino, 2009).

Later, visiting the tavern to investigate the killings, Landa finds one of Hammersmark's shoes. The scent of suspicion he detects in them is further enhanced when he meets Hammersmark and her three brothers-in-arms (Basterds, that is) at the opening of *Stoltz der Nation*. Posing as Italians, Donowitz, 'The Bear Jew', and PFC Omar Ulmer, played by Omar Doom (which *is* his actual name), give themselves away with their incredulous accents, bordering on the absurd; it is the white-tuxedoed Raine whose accent is the most outlandish, however – a Tarantino conceit. At the same time, this vignette is emblematic of Tarantino's humour that at times borders on slapstick. So it should come as no surprise that Colonel Landa, who is fluent in Italian, French and English, realizes something is very wrong. He sends Donowitz and Ulmer to their seats, and then requests that Hammersmark join him privately. We are now back to where I began. Sitting in close proximity to each other, Landa asks Hammersmark to place her (right) foot in his lap.

She responds, 'Hans . . . You embarrass me.' He simply reacts by pointing emphatically at his lap. She acquiesces. These few words I've just quoted are from the script itself, which, looked at more closely, reveals discrepancies between the script and the film. Some are insignificant; others are not. Take this excerpt, for example:

> The nervous fraulein, lifts up her strapy [sic] dress shoe enclosed foot, and places it in the Colonel's lap. The Colonel, very delicately, unfastens the thin straps that hold the frauleins [sic] shoe on her foot. He removes the shoe leaving only the frauleins [sic] bare foot . . . He removes from his heavy ss coat pocket the pretty dress shoe the fraulein left behind at La Louisiane [the tavern where the dreadful shootings took place]. He slips it on her foot.[42]

In the film, by contrast, the Colonel does not take the shoe from his overcoat. On the contrary, he asks the fraulein to put her hand into its right pocket and hand to him what she finds there: it is one of her shoes, of course – she is devastated. In shifting Hammersmark's 'guilt', as it were, from Landa to her, she becomes an accomplice in her own undoing. Dramatically and emotionally, it is a far more affecting sequence than the one outlined in the script.

Landa takes her shoe and places it on her foot (illus. 60 and 61). It fits perfectly. 'Voila!', he says. 'What is the American expression? If the shoe fits, you must wear it.' In the hands of the smarmy Colonel, this denouement is simple and sharp. What soon follows is the killing of Hammersmark, which I will discuss after I make these two points. First, the Cinderella narrative discussed elsewhere in my

text is obviously at work here, although in the fairy tale the king's page lets Cinderella try on the glass slipper, which, fitting perfectly, results in her marriage to the king and them both living happily ever after. Second, I have the hunch that in putting these words into The Colonel's mouth – 'If the shoe fits, you must wear it' – Tarantino artfully references the infamous trial of O. J. Simpson (1995), during which Johnnie Cochran (1937–2005), leading the defence team, said in respect of the bloodied glove found at the scene of the murder of Nicole Brown Simpson and Ronald Lyle Goldman, 'If it [the glove]

60 and 61 Bridget von Hammersmark's feet being handled by Hans Landa in *Inglourious Basterds* (2009).

62 and 63 Bridget von Hammersmark's bandaged foot (top) and below, her prostrate, dead body, in *Inglourious Basterds* (2009).

doesn't fit you must acquit', a pronouncement that very soon entered into the mythology of this remarkable televised trial.

The Colonel's killing of the undercover agent is ostentatious. Lunging at her and throwing her to the ground – both of them now screaming – he places his hands around her neck. Her feet kick here, there and everywhere. But it is on Hammersmark's left foot, ensconced in a cumbersome plaster cast (from the injuries she had incurred at 'La Louisiane') that the camera indulges (illus. 62). Her dying moments show her feet, one naked, healthy and desirable, and the other 'mummified', as it were, shaking pathetically, in ways that recall the struggling feet of the dying medical orderly in *Kill*

Bill: Volume 2 (illus. 63). Tarantino's closing shot would surely have pleased Caravaggio. There's the chiaroscuro – pronounced; there's a low, foreshortened perspective; and there are two feet looking out at us, in our face – up front and personal.

Conclusion

I n Shakespeare's *Troilus and Cressida*, Ulysses says of Cressida's foot that it 'speaks' of seduction.[1] The foot 'speaks' clearly – and loudly – in the pages of this book but in ways that go far beyond Shakespeare's limited brief. Through literary texts, art, sport and film, the foot steps in many directions, touching variously on the seductive and the abject; the sublime and the absurd; the frivolous, ironic and pragmatic. We have been through the work of Gautier, Bataille and the photographer Boiffard, seeking to stretch our understanding of the foot in ways that make us radically rethink our conceptual and visual understandings of this simple appendage, and proceeded with an examination of Western, religious paintings that present the foot as a receptacle for righteousness and sanctity, cleanliness and transcendence. This has been followed by a study of bare feet in elite running and their ties to ethnicity, the 'natural' and ambition, and concluded with my final chapter, which moved through film's capricious representations of feet, ranging from the sexy and the frivolous to the quirky and the sombre.

The television movie *Their Eyes Were Watching God* (dir. Darnell Martin, 2005) invites consideration here. We see the actor Halle

Berry as the character Janie Crawford, stepping from the immediate 'front' of the screen, as it were, into its 'depths'. First, there are her feet, and nothing more, briefly one after the other, stepping on a moist, gravel surface, but not leaving, surprisingly, any suggestion of a footprint. An intentional directorial choice or otherwise, this absence intrigues me. Both the sole – and the palm for that matter – are able to leave behind the 'identity' of their owner. Halle's insubstantial footprint, however, throws into question the corporeality of the foot and its relationship to its 'owner' – conceit, to be sure, but one which appeals to me, suggesting, just suggesting, that with the foot nothing can be taken for granted. To put it another way, there is no foothold with the foot.

REFERENCES

1 The Mummy's Foot

1 See Richard Hobbs, ed., *From Balzac to Zola: Selected Short Stories* (Bristol, 1992), p. 13.
2 See Madeleine Dobie's excellent study, *Foreign Bodies: Gender, Language, and Culture in French Orientalism* (Stanford, CA, 2001), especially pp. 147–69.
3 F. Elizabeth Dahab, 'Théophile Gautier and the Orient', CLC Web: *Comparative Literature and Culture*, 1/4 (1999), http://docs.lib. purdue.edu, accessed 23 April 2015, p. 2.
4 Ibid., p. 310.
5 Ibid., p. 308.
6 Théophile Gautier, 'The Mummy's Foot' [1840], trans. Lafcadio Hearn (New York, 1908), www.gutenberg.org, accessed 9 February 2013, unpaginated.
7 Ibid.
8 Ibid.
9 Ibid.
10 Ibid.
11 Ibid.
12 Ibid.
13 Ibid.
14 Ibid.
15 Ibid.
16 Ibid.
17 Ibid.
18 Ibid.

19 Ibid.

20 Ibid.

21 Ibid.

22 Ibid.

23 Ibid.

24 Hobbs, *From Balzac to Zola*, p. 12.

25 See, for example, Patricia S. Han, 'Reading Irony across Cultures', *Language and Literature*, XXVII (October 2002), p. 27; also, Jutta Emma Fortin, *Method in Madness: Control Mechanisms in the French Fantastic* (Amsterdam and New York, 2005), pp. 46–53.

26 Hobbs, *From Balzac to Zola*, p. 14.

27 Sima Godfrey, 'Mummy Dearest: Cryptic Codes in Gautier's "Pied de Mommie"', *Romantic Review*, LXXV/3 (May 1989), p. 302.

28 Gautier, 'The Mummy's Foot', n.p.

29 See Sigmund Freud, 'Fetishism', *Miscellaneous Papers* (5 vols), (London, 1924–50), vol. V, p. 200.

30 Fortin, *Method in Madness*, p. 46.

31 Ibid., pp. 46–7, my emphasis. Fortin cites p. 71 of Karl Marx, 'The Fetishism of Commodities and the Secret Thereof', in *Capital: A Critique of Political Economy* (New York, 1968), vol. I., pp. 71–81.

2 The Big Toe and the Strange Feet

1 Benjamin Noys, *Georges Bataille: A Critical Introduction* (London and Sterling, VA, 2000), https:// books.google.com.au, accessed 17 October 2014, p. 31.

2 Olivier Chow, 'Idols/Ordures: Inter-repulsion in *Documents'* Big Toes', *Drain Magazine*, www.drainmag.com, accessed 23 October 2014, unpaginated.

3 Georges Bataille, *Encyclopaedia Acephalica: Comprising the Critical Dictionary and Related Texts*, assembled by Alastair Brotchie, trans. Ian White (London, 1995), n.p.

4 Bataille, entry for 'Spittle', ibid., p. 79.

5 Bataille, entry for 'Big Toe', ibid., p. 87.

6 Ibid.

7 See Michael Richardson , 'Introduction', in Georges Bataille, *Georges Bataille: Essential Writings*, ed. Michael Richardson (London, and New Delhi, 1998), p. 2.

8 Ibid., p. 12.

9 Bataille, 'Big Toe', p. 87.

10 Ibid., p. 92.

11 Ibid.

12 Ibid.

13 Ibid.

14 Ibid.

15 See chap. 12 in D. H. Lawrence, *Lady Chatterley's Lover* [1928], www.gutenberg.net.au, accessed 20 June 2016, unpaginated.

16 The three photographs include two of male toes and one of a female toe. Each photograph is full-page. They are intimate close-ups, the toes filling the ambiguous black background of the image in ways that impose their presence on the viewer.

17 Chow, 'Idols/Ordures', n.p.

18 Tremper Longman III and David Garland, general eds, *The Expositor's Bible Commentary: Proverbs–Isaiah* (13 vols), revd edn (Grand Rapids, MI, 2008), vol. VI, p. 406.

19 Pat Brassington, quoted in Ashley Crawford, 'Pat Brassington: Totems and Taboos', *Australian Art Collector*, 35 (January–March 2006), p. 83.

20 '*der Wilden und der Neurotiker*', in the original German.

21 Crawford, 'Pat Brassington', p. 81.

22 Brassington, quoted ibid., p. 83.

23 Ibid., p. 81.

24 Ibid., p. 83.

3 The Sacred, the Dirty and the Shocking

1 Zhou Guizen, quoted in Louisa Lim, 'Painful Memories for China's Foot-binding Survivors', NPR (19 March 2007), www.npr.org.

2 See *Arthashastra*, Book 1, chap. 19, www.hinduwebsite.com, accessed 15 January 2015. *Arthashastra* is an ancient Indian treatise, written in Sanskrit, that deals with statecraft, economics and military strategy.

3 See www.gotquestions.org, accessed 16 January 2015; www.ucg.org, accessed 16 January 2015.

4 John 13:6–8.

5 Anon., 'The Exhibition of the Royal Academy, 1852, the Eighty-fourth', *Art Journal* (1 June 1852), p. 173. A basic history of Ford Madox Brown was included in his catalogue essay *1865 Exhibition of Work and Other Paintings*, transcribed in Kenneth Bendiner, *The Art of Ford Madox Brown* (University Park, PA, 1998), p. 135.

6 Matthew 26:8; John 12:6.

7 John 12:3; Luke, 7:38. Although Mary is not mentioned by name in Luke and is only alluded to as a 'sinner', the two stories are identical in many respects.

8 Luke 7:39.

9 See, for example, 'Was Mary Magdalene Wife of Jesus? Was Mary Magdalene a Prostitute?', *Bible History Daily*, www.biblicalarchaeology.org, accessed 17 July 2015; see also Birger A. Pearson, 'From Saint to Sinner', *Bible Review* (Spring 2005), pp. 36–7.

10 Luke 7:36–50.

11 See Daniel 13:15–16.

12 Claude Phillips, 'The Summer Exhibitions at Home and Abroad, IV: The Salons of the Champs Élysées and the Champ de Mars', *Art Journal* (August 1891), pp. 248–9, my emphasis.

13 Our Correspondent, 'The Champ de Mars Salon', *Daily News* [London] (15 May 1891), p. 4.

14 See Alan Krell, 'Dirt and Desire: Troubled Waters in Realist Practice', in *Impressions of French Modernity: Art and Literature in France, 1850–1900*, ed. Richard Hobbs (Manchester, 2002), pp. 135–54.

15 In using the term 'absorption', I refer of course to the art historian Michael Fried and his championing of this concept; see, for example, Michael Fried, *Manet's Modernism: or, The Face of Painting in the 1860s* (Chicago, IL, 1996).

16 Théophile Gautier, 1864, quoted in George Heard Hamilton, *Manet and his Critics* (New York, 1969), p. 99, and repeated in Françoise Cachin et al., *Manet 1832–1883*, exh. cat., Galeries

Nationales du Grand Palais, Paris, and The Metropolitan Museum of Art, New York (New York, 1983), p. 203.

17 Karl Marx, *The Eighteenth Brumaire of Louis Bonaparte* (New York, 1852), chap. VII, www.marxists.org, accessed 26 May 2015, unpaginated.

18 See, for example, Peter Hayes, 'Marx's Analysis of the French Class Structure', *Theory and Society*, XXII/1 (February 1993), pp. 99–123; see also Nicholas Thoburn, 'Difference in Marx: The Lumpenproletariat and the Proletarian Unnameable', *Economy and Society*, XXXI/3 (August 2002), pp. 434–60.

19 Alan Krell, *Manet and the Painters of Contemporary Life* (London, 1996), p. 65.

20 Quoted in James Hall, 'Caravaggio: Prince of Darkness', www.theguardian.com, 10 April 2010.

21 See Laura Rorato, *Caravaggio in Film and Literature: Popular Culture's Appropriation of a Baroque Genius* (Oxford, 2014); Peter Conrad, 'Caravaggio: A Life Sacred and Profane', review of Andrew Graham-Dixon, *Caravaggio: A Life Sacred and Profane* (London, 2010), www.theguardian.com, 27 June 2010.

22 Giovanni Baglione, *Le vite de' pittori, scultori et architetti, dal pontificato di Gregorio xiii del 1572 in fino a'tempi di papa Urbano Ottavo nel 1642* (Rome, 1642), p. 137, quoted in John T. Spike, *Caravaggio* (2nd revd edn, New York, 2010), p. 149.

23 Francesco Scannelli, *Il microcosmo della pittura* (Cesena, 1657), quoted ibid.

24 Ibid. pp. 149, 188; Howard Hibbard, *Caravaggio* (London, 1983), p. 187, my emphasis.

25 Ibid., p. 190, my emphasis.

26 Hibbard, *Caravaggio*, p. 197.

27 See ibid.

28 Catherine Puglisi, *Caravaggio* (London, 1998), p. 193.

29 See Dorothy Ko, *Every Step a Lotus: Shoes For Bound Feet* (Berkeley, CA, 2001).

30 See Dorothy Ko's authoritative *Cinderella's Sisters: A Revisionist History of Foot-binding* (Los Angeles, CA, and London, 2005). See also Zài Jiàn and Renée Aloha, 'Chinese Foot Binding – The Wūzhèn Foot-binding Museum: Why Did the Practice Start?

What Was the Foot-binding Process? Who Tried to Stop It? Is Anything Like It Happening Today?', https://reneeriley. wordpress.com, 27 June 2011; and Laurel Bossen et al., 'Feet and Fabrication: Foot-binding and Early Twentieth-century Rural Women's Labor in Shaanxi', *Modern China*, XXXVII/4 (July 2011), pp. 347–83, http://mcx.sagepub.com, accessed 7 July 2015.

31 Zhou Guizen, in Lim, 'Painful Memories for China's Foot-binding Survivors'.

32 See Melissa J. Brown et al., 'Marriage Mobility and Foot-binding in Pre-1949 Rural China: A Reconsideration of Gender, Economics, and Meaning in Social Causation', *Journal of Asian Studies*, LXXI/4 (2012), p. 1037.

33 Angharad Hampshire, 'My Life: Jo Farrell', *Post Magazine*, www.scmp.com, 7 December 2014. Farrell's is not an isolated voice. A proliferation of writings about foot-binding – scholarly and otherwise – and YouTube's uneven but occasionally pointed contributions, has added to an understanding of the practice. Importantly, there are more recent revisionist histories; notably, I would suggest, those of Dorothy Ko, a professor of history at Barnard College, Columbia University, and Sheng-mei Ma, a professor of English at Michigan State University.

34 Jo Farrell, quoted in Nina Strochic, 'China's Last Foot-binding Survivors', *The Daily Beast*, www.thedailybeast.com, 2 July 2014.

35 'Unbound, China's Last "Lotus Feet" – in Pictures', www.theguardian.com, 15 June 2015.

36 Su Lian-qi quoted in Li Xiu-ying, 'Women with Bound Feet in China: Excerpts from *When I Was a Girl in China*, Stories Collected by Joseph Rupp', in *Reshaping the Body: Clothing and Cultural Practice*, Historical Collections at the Claude Moore Health Sciences Library, University of Virginia, http://exhibits. hsl.virginia.edu, accessed 20 July 2015.

37 Ko, *Every Step a Lotus*, p. 30.

38 Cao Zijian, 'Rhapsody on the Luo River Goddess', in Xia Tong, *Wen Xuan, or Selections of Refined Literature*, trans. David R. Knechtges (Princeton, NJ, 1996), pp. 355–65. Quoted by Dorothy Ko in *Every Step a Lotus*, p. 30.

39 Han Wo, 'Ode to Slippers', quoted in Ko, *Every Step a Lotus*, p. 31.

4 Baring Your Sole

1 Reproduced in Tim Ingold, 'Culture on the Ground: The World Perceived Through the Feet', *Journal of Material Culture*, IX/3 (2004), p. 316.
2 Ibid., p. 315.
3 Ibid., p. 319.
4 Ibid.
5 See, for example, Matthew Karsten, 'Running with Mexico's Tarahumara Indians', *Expert Vagabond*, http://expertvagabond.com, accessed 12 September 2015.
6 Scott Douglas, *The Runner's World Complete British Runner: Complete Guide to Minimalism and Barefoot Running* (New York, 2013), p. 48.
7 Ibid.
8 See Katie Thomas, 'Running Shorts. Singlet. Shoes?', www.nytimes.com, 2 November 2010.
9 Douglas, *Runner's World*, p. 48.
10 Christopher McDougall, *Born to Run: The Hidden Tribe, The Ultra-runners, and The Greatest Race the World Has Never Seen* (London, 2010), p. 145.
11 Shankarah Smith quoted ibid., inside jacket; *Men's Health* quoted in McDougall, *Born to Run*, inside jacket.
12 Lloyd Bradley quoted in *The Rough Guide to Running*, quoted in McDougall, *Born to Run*, inside jacket.
13 'Black History Salute! To Abebe Bikila and the Trailblazing African Running Phenomenon!', www.rbgfitclub.com, accessed 22 March 2013.
14 Tim Judah, 'The Glory Trail', www.theguardian.com, 26 July 2008, edited extract from Tim Judah, *Bikila: Ethiopia's Barefoot Olympian* (London, 2009).
15 Judah, *Bikila*, p. 40; see also Judah, 'Glory Trail'.
16 Robin Harvie, *The Lure of Long Distances: Why We Run* (New York, 2011), p. 133.
17 'Abebe Bikila Wins Marathon in 1960 Olympics . . . Barefoot' [video], YouTube, www.youtube.com, accessed 15 March 2013.

18 'Rome 1960 Marathon: Marathon Week' [video], YouTube, www.youtube.com, accessed 20 February 2013.

19 Ibid.

20 See Edward W. Said, *Orientalism* (London, 1978).

21 Judah, *Bikila*, pp. 85–6.

22 Quoted in 'Robin Williams Talks about His Favorite Runner Abebe Bikila' [video], YouTube, www.youtube.com, accessed 28 October 2015. My transcription.

23 Zola Budd quoted in Peter Larson and Bill Katovsky, *Tread Lightly: Form, Footwear, and the Quest for Injury-free Running* (New York, 2012), p. 51.

24 See Steven J. Overman and Kelly Boyer Sagert, *Icons of Women's Sport: From Tomboys to Title IX and Beyond* (Santa Barbara, CA, Denver, CO, and Oxford, 2012), vol. I, p. 56; Zola Budd and Hugh Eley, *Zola: The Autobiography of Zola Budd* (London, 1989), p. 19.

25 Ibid., p. 22.

26 See ibid., p. 26.

27 Ibid.

28 Frank Budd, Zola's father, had little affection for his three children; for example, his will (1989) disclosed that his three daughters were not welcome at his funeral. For this, see 'Zola Budd, Sisters are Not Welcome at Father's Funeral, Report Claims', *Los Angeles Times*, 27 September 1989, available at http://articles.latimes.com.

29 Budd and Eley, *Zola*, p. 48.

30 Ibid., p. 51.

31 Ibid.

32 Ibid., p. 48.

33 Ibid., pp. 190–93.

34 Ibid., p. 30.

35 Ibid., pp. 30–31.

36 Ibid., p. 31.

37 Ibid.

38 David English, quoted in David Burnton, '50 Stunning Olympic Moments No. 30: Zola Budd's Rise and Fall in 1984', www.theguardian.com, 15 May 2012.

39 Ibid.

40 Steve Friedman, 'After the Fall', *Runner's World*, 7 May 2013, available at www.runnersworld.com; my emphasis.

41 Frank Keating, 'Ian Wooldridge' [obituary], www.theguardian.com, 6 March 2007.

42 Budd and Eley, *Zola*, p. 48.

43 Rob Evans and Paul Kelso, 'How a Runner Named Budd Split the Tories', www.theguardian.com, 10 August 2005.

44 Ibid.

45 Ibid.

46 Ibid.

47 Budd and Eley, *Zola*, p. 75.

48 Ibid.

49 See ibid., pp. 76–7.

50 David F. Martin and Roger W. H. Gynn, *The Olympic Marathon: The History and Drama of Sport's Most Challenging Event* (Champaign, IL, 2000), p. 3.

51 'Women's 3000m Olympic Final – Los Angeles 1984' [video], YouTube, www.youtube.com, accessed 19 May 2015.

52 Jedi Ramalapa, 'The Sweetness of Brenda Fassie's Zola Budd', https://sowhatsart.wordpress.com, 1 November 2012.

53 Ibid.

5 The Filmic Foot

1 Tess Morris, 'Clip Joint: Bare Feet', www.theguardian.com, 20 September 2015.

2 'Top Ten Foot Fetish Movie Scenes', *The Feethunter*, http://thefeethunter.com, 27 December 2014.

3 Morris, 'Clip Joint'.

4 *Modern Times*, dir. Charlie Chaplin, 1936 (DVD: Warner Home Video, 2006).

5 'The Gamin: Paulette Goddard', www.charliechaplin.com, accessed 9 February 2016. At the time, Goddard was married to Chaplin (they divorced in 1942). Goddard would go on to feature in Chaplin's first talkie, *The Great Dictator* (1940), a remarkable comedic take on fascism and the rise of Hitler.

6 *Modern Times*, intertitle.

7 *The Adventures of Huckleberry Finn*, dir. Richard Thorpe, 1939 (DVD: Warner Home Video, 2009).

8 Paul Tatara, 'The Adventures of Huckleberry Finn (1939)', www.tcm.com, accessed 10 February 2016.

9 Ibid.

10 *My Left Foot*, dir. Jim Sheridan, 1989 (DVD: Lionsgate Home Entertainment/Miramax, 2015).

11 See Georgina Louise Hambleton, *Christy Brown: The Life that Inspired My Left Foot* (Edinburgh, 2012).

12 See, for example, Pieter Bosman, 'Footloose and Fancy Free', www.worldwidewords.org, accessed 19 February 2016, and 'Footloose', http://dictionary.cambridge.org, accessed 20 February 2015.

13 *Roman Holiday*, dir. William Wyler, 1953 (DVD: Paramount Home Video, 2006).

14 *Roman Holiday* script, www.script-o-rama.com, accessed 19 February 2015.

15 See, for example, Nargiz Koshoibekova, 'Ancient Chinese Cinderella Story', www.theworldofchinese.com, 22 March 2015; 'Cinderella Around the World', www.edenvalleyenterprises.org, accessed 21 February 2016; and Dorothy Ko, *Cinderella's Sisters: A Revisionist History of Foot-binding* (Berkeley and Los Angeles, CA, and London, 2005).

16 See '2015 Cinderella Slipper, Limited Edition', www.swarovski.com, accessed 22 February 2016. An object of desire – yes. A fetish – certainly.

17 *The Barefoot Contessa*, dir. Joseph L. Mankiewicz, 1954 (DVD: MGM Home Entertainment, 2007).

18 François Truffaut quoted in www.moviediva.com, accessed 3 March 2016.

19 Joel Bocko, 'Hooray for (Hating) Hollywood: The Barefoot Contessa', http://thedancingimage.blogspot.com.au, 27 September 2008; see also Asotir, 'The Barefoot Contessa', http://asotir-movieletters.blogspot.co.uk/2009/04/barefoot-contessa.html, 19 April 2009.

20 *Barefoot in the Park*, dir. Gene Saks, 1967 (DVD: Paramount Home Entertainment, 2007).

21 Roger Ebert, review of *The Butcher's Wife*, www.rogerebert.com, 25 October 1991; *The Butcher's Wife*, dir. Terry Hughes, 1991 (DVD: Paramount Home Video, 2001).

22 'The Tales of Ba Sing Se', chap. 15, in *Avatar: The Last Airbender: Book Two: Earth, Volume Three* (2007), written by Joann Estoesta and Lisa Wahlander (DVD: Nickelodeon/Nickelodeon Avatar, 2007).

23 See Jessica Satherley, 'Uma Thurman Toasts Quentin Tarantino's Foot Fetish . . . With Her Champagne-filled Christian Louboutins', www.dailymail.co.uk, 6 December 2010.

24 Leon Markovitz, 'Quentin Tarantino's Foot Fetish, Measured: How Often Does the Bare Female Foot Appear in His Films?', www.vocativ.com/news, 27 December 2015.

25 See, for example, Mike Kelley, *The Uncanny*, exh. cat., Tate Liverpool, Liverpool, and Museum Moderner Kunst Stiftung Ludwig Wien, Vienna (Cologne, 2004); Anna Balakian, *Surrealism: The Road to the Absolute* [1959] (3rd edn, Chicago, IL, 1986).

26 Sigmund Freud, 'The "Uncanny"' (1919), http://web.mit.edu, accessed 21 March 2016, pp. 1–2.

27 Ibid., p. 9.

28 Ibid.

29 Ibid.

30 *Kill Bill: Volume 1*, dir. Quentin Tarantino, 2003 (DVD: Lionsgate/ Miramax, 2004).

31 Roger Ebert, review of *Kill Bill: Volume 1*, www.rogerebert.com, 10 October 2003.

32 *Kill Bill: Volume 2*, dir. Quentin Tarantino, 2004 (DVD: Lionsgate/ Miramax, 2008).

33 See Michael Fried, *Manet's Modernism: or, The Face of Painting in the 1860s* (Chicago, IL, and London, 1996).

34 Georges Bataille, *Story of the Eye* (Paris, 1928), trans. Joachim Neugroschal, available at http://ps28.squat.net, accessed 9 April 2016, pp. 1–47.

35 Ibid., p. 1.

36 Ibid., p. 28.

37 Ibid., p. 29.

38 Ibid.

39 See, for example, Chris Vanderwees, 'Complicating Eroticism and the Male Gaze: Feminism and Georges Bataille's *Story of the Eye*', *Studies in 20th and 21st Century Literature*, XXXVIII/1 (2014), http://newprairiepress.org, accessed 13 April 2016, pp. 1–17.

40 Ladelle McWhorter, 'Bataille's Erotic Displacement of Vision', in *Panorama: Philosophies of the Visible*, ed. Wilhelm S. Wurzer (New York, 2002), p. 118, quoted by Vanderwees in 'Complicating Eroticism', p. 12. See also Courtney Bissonette, 'A Feminist Defense of Quentin Tarantino', http://bust.com, accessed 13 April 2016.

41 *Inglourious Basterds*, dir. Quentin Tarantino, 2009 (DVD: Visiona Romantica/The Weinstein Company, 2009).

42 See Quentin Tarantino, *Inglourious Basterds* script, www.imsdb.com, accessed 17 April 2016.

Conclusion

1 William Shakespeare, *Troilus and Cressida*, in *William Shakespeare: The Complete Works: The Edition of the Shakespeare Head Press, Oxford* (New York, 1994), p. 741.

Bibliography

Arthashastra, www.hinduwebsite.com, accessed 15 January 2015

Balakian, Anna, *Surrealism: The Road to the Absolute* [1959], 3rd edn (Chicago, IL, 1986)

—, *Encyclopaedia Acephalica: Comprising the Critical Dictionary and Related Texts*, assembled by Alastair Brotchie, trans. Ian White (London, 1995)

—, *Story of the Eye*, trans. Joachim Neugroschal (Paris, 1928), http://ps28.squat.net, accessed 9 April 2016

Bendiner, Kenneth, *The Art of Ford Madox Brown* (University Park, PA, 1998)

Bissonette, Courtney, 'A Feminist Defense of Quentin Tarantino', http://bust.com, accessed 13 April 2016

Bossen, Laurel, et al., 'Feet and Fabrication: Footbinding and Early Twentieth-century Rural Women's Labor in Shaanxi', *Modern China*, XXXVII/4 (July 2011), pp. 347–83, available at http://mcx.sagepub.com, accessed 7 July 2015

Brown, Melissa J., et al., 'Marriage Mobility and Footbinding in Pre-1949 Rural China: A Reconsideration of Gender, Economics, and Meaning in Social Causation', *Journal of Asian Studies*, LXXI/4 (2012), pp. 1035–67

Budd, Zola, and Hugh Eley, *Zola: The Autobiography of Zola Budd* (London, 1989)

Burnton, David, '50 Stunning Olympic Moments No. 30: Zola Budd's Rise and Fall in 1984', www.theguardian.com, 15 May 2012

Cachin, Françoise, et al., *Manet: 1832–1883*, exh. cat., Galeries Nationales du Grand Palais, Paris, and The Metropolitan Museum of Art, New York (New York, 1983)

Chow, Olivier, 'Idols/Ordures: Inter-repulsion in *Documents'* Big Toes', *Drain Magazine*, www.drainmag.com, accessed 23 October 2014

Conrad, Peter, 'Caravaggio: A Life Sacred and Profane', review of Andrew Graham-Dixon, *Caravaggio: A Life Sacred and Profane* (London, 2010), www.theguardian.com, 27 June 2010

Crawford, Ashley, 'Pat Brassington: Totems and Taboos', *Australian Art Collector*, 35 (January–March 2006)

Dahab, F. Elizabeth, 'Theophile Gautier and the Orient', *CLC Web: Comparative Literature and Culture*, 1/4 (1999), http://docs.lib. purdue.edu, accessed 23 April 2015, pp. 1–7

Dobie, Madeleine, *Foreign Bodies: Gender, Language, and Culture in French Orientalism* (Stanford, CA, 2001)

Douglas, Scott, *The Runner's World Complete British Runner: Complete Guide to Minimalism and Barefoot Running* (New York, 2013)

Fortin, Jutta Emma, *Method in Madness: Control Mechanisms in the French Fantastic* (Amsterdam and New York, 2005), pp. 46–53

Freud, Sigmund, 'Fetishism', *Miscellaneous Papers* (5 vols) (London 1924–50), vol. v, pp. 198–204

Freud, Sigmund, 'The "Uncanny"' (1919), http://web.mit.edu, accessed 21 March 2016

Fried, Michael, *Manet's Modernism: or, The Face of Painting in the 1860s* (Chicago, IL, and London, 1996)

Friedman, Steve, 'After the Fall', www.runnersworld.com, 7 May 2013

Gautier, Théophile, 'The Mummy's Foot' [1840], trans. Lafcadio Hearn (New York, 1908), www.gutenberg.org, accessed 9 February 2013

Giovanni Baglione, *Le vite de' pittori, scultori et architetti, dal pontifico di Gregorio XII del 1572 in fino a' tempa di papa Urbano Ottavo nel 1642* (Rome, 1642)

Godfrey, Sima, 'Mummy Dearest: Cryptic Codes in Gautier's "Pied de Mommie"', *Romantic Review*, LXXV/3 (May 1989), pp. 302–11

Hall, James, 'Caravaggio: Prince of Darkness', www.theguardian.com, 10 April 2010

Hambleton, Georgina Louise, *Christy Brown: The Life that Inspired My Left Foot* (Edinburgh, 2012)

Hamilton, George Heard, *Manet and His Critics* (New York, 1969)

Hampshire, Angharad, 'My Life: Jo Farrell', *Post Magazine*, www.scmp.com, 7 December 2014

Han, Patricia S., 'Reading Irony Across Cultures', *Language and Literature*, XXVII (October 2002), pp. 27–48

Harvie, Robin, *The Lure of Long Distances: Why We Run* (New York, 2011)

Hayes, Peter, 'Marx's Analysis of the French Class Structure', *Theory and Society*, XXII/1 (February 1993), pp. 99–123

Hibbard, Howard, *Caravaggio* (London, 1983)

Hobbs, Richard, ed., *From Balzac to Zola: Selected Short Stories* (Bristol, 1992)

Ingold, Tim, 'Culture on the Ground: The World Perceived Through the Feet', *Journal of Material Culture*, IX/3 (2004), pp. 316–40

Jiàn, Zài, and Renée Aloha, 'Chinese Foot Binding – The Wūzhèn Foot-binding Museum: Why Did the Practice Start? What Was the Foot-binding Process? Who Tried to Stop It? Is Anything Like it Happening Today?', https://reneeriley.wordpress.com, 27 June 2011

Judah, Tim, *Bikila: Ethiopia's Barefoot Olympian* (London, 2009)

Karsten, Matthew, 'Running with Mexico's Tarahumara Indians', *Expert Vagabond*, http://expertvagabond.com, accessed 12 September 2015

Kelley, Mike, et al., *The Uncanny*, exh. cat., Tate Liverpool, Liverpool, and Museum Moderner Kunst Stiftung Ludwig Wien, Vienna (Cologne, 2004)

Ko, Dorothy, *Cinderella's Sisters: A Revisionist History of Footbinding* (Los Angeles, CA, and London, 2005)

—, *Every Step a Lotus: Shoes For Bound Feet* (Berkeley, CA, 2001)

Krell, Alan, 'Dirt and Desire: Troubled Waters in Realist Practice', in *Impressions of French Modernity: Art and Literature in France, 1850–1900*, ed. Richard Hobbs (Manchester, 2002), pp. 135–54

—, *Manet and the Painters of Contemporary Life* (London, 1996)

Larson, Peter, and Bill Katovsky, *Tread Lightly: Form, Footwear, and the Quest for Injury-free Running* (New York, 2012)

Lawrence, D. H., *Lady Chatterley's Lover* [1928], www.gutenberg.net.au, accessed 20 June 2016

Lim, Louisa, 'Painful Memories for China's Footbinding Survivors',
 www.npr.org, 19 March 2007
Longman III, Tremper, and David Garland, general eds, *The Expositor's
 Bible Commentary: Proverbs–Isaiah* (13 vols) revd edn
 (Grand Rapids, MI, 2008), vol. VI
McDougall, Christopher, *Born to Run: The Hidden Tribe, The
 Ultra-runners, and The Greatest Race the World Has Never Seen*
 (London, 2010)
McWhorter, Ladelle, 'Bataille's Erotic Displacement of Vision', in
 Panorama: Philosophies of the Visible, ed. Wilhelm S. Wurzer
 (New York, 2002)
Martin, David F., and Roger W. H. Gynn, *The Olympic Marathon:
 The History and Drama of Sport's Most Challenging Event*
 (Champaign, IL, 2000)
Marx, Karl, *The Eighteenth Brumaire of Louis Bonaparte* (New York,
 1852), www.marxists.org, accessed 26 May 2015
Marx, Karl, 'The Fetishism of Commodities and the Secret Thereof',
 in *Capital: A Critique of Political Economy*, I (New York, 1968),
 pp. 71–81
Noys, Benjamin, *Georges Bataille: A Critical Introduction* (London
 and Sterling, VA, 2000), https://books.google.com.au, accessed
 17 October 2014
Our Correspondent, 'The Champ de Mars Salon', *Daily News*
 [London], 15 May 1891
Overman, Steven J., and Kelly Boyer Sagert, *Icons of Women's Sport:
 From Tomboys to Title IX and Beyond* (Santa Barbara, CA, Denver,
 CO, and Oxford, 2012), vol. I
Puglisi, Catherine, *Caravaggio* (London, 1998)
Ramalapa, Jedi, 'The Sweetness of Brenda Fassie's Zola Budd',
 https://sowhatsart.wordpress.com, 1 November 2012
Richardson, Michael, 'Introduction', in Georges Bataille, *Georges
 Bataille: Essential Writings*, ed. Michael Richardson (London and
 New Delhi, 1998), pp. 1–4
Rorato, Laura, *Caravaggio in Film and Literature: Popular Culture's
 Appropriation of a Baroque Genius* (Oxford, 2014)
The Rough Guide to Running (London, 2007)
Said, Edward W., *Orientalism* (London, 1978)

Shakespeare, William, *Troilus and Cressida*, in *William Shakespeare: The Complete Works: The Edition of the Shakespeare Head Press, Oxford* (New York, 1994), pp. 714–52

Spike, John T., *Caravaggio*, 2nd revd edn (New York, 2010)

Strochic, Nina, 'China's Last Foot-binding Survivors', www.thedailybeast.com, 2 July 2014, unpaginated

Tatara, Paul, 'The Adventures of Huckleberry Finn (1939)', www.tcm.com, accessed 10 February 2016

Thoburn, Nicholas, 'Difference in Marx: The Lumpenproletariat and the Proletarian Unnameable', *Economy and Society*, XXXI/3 (August 2002), pp. 434–60

Thomas, Katie, 'Running Shorts. Singlet. Shoes?', www.nytimes.com, 2 November 2010

Tong, Xia, *Wen Xuan, or Selections of Refined Literature*, trans. David R. Knechtges (Princeton, NJ, 1996)

'Unbound: China's Last "Lotus Feet" – in Pictures', www.theguardian. com, 15 June 2015

Vanderwees, Chris, 'Complicating Eroticism and the Male Gaze: Feminism and Georges Bataille's *Story of the Eye*', *Studies in 20th and 21st Century Literature*, XXXVIII/1 (2014), http:// newprairiepress.org, accessed 13 April 2016, pp. 1–17

Li Xiu-ying, 'Women with Bound Feet in China: Excerpts from *When I Was a Girl in China*, Stories Collected by Joseph Rupp', in *Reshaping the Body: Clothing and Cultural Practice*, Historical Collections at the Claude Moore Health Sciences Library, University of Virginia, http://exhibits.hsl.virginia.edu, accessed 20 July 2015

Films

The Adventures of Huckleberry Finn, dir. Richard Thorpe, 1939 (DVD: Warner Home Video, 2009)

The Barefoot Contessa, dir. Joseph L. Mankiewciz, 1954 (DVD: MGM Home Entertainment, 2007)

Barefoot in the Park, dir. Gene Saks, 1967 (DVD: Paramount Home Entertainment, 2007)

The Butcher's Wife, directed by Terry Hughes, 1991 (DVD: Paramount Home Video, 2001)

Kill Bill: Volume 1, dir. Quentin Tarantino, 2003 (DVD: Lionsgate/Miramax, 2004)

Kill Bill: Volume 2, dir. Quentin Tarantino, 2004 (DVD: Lionsgate/Miramax, 2008)

Modern Times, dir. Charlie Chaplin, 1936 (DVD: Warner Home Video, 2006)

My Left Foot, dir. Jim Sheridan, 1989 (DVD: Lionsgate Home Entertainment/Miramax, 2015)

Roman Holiday, dir. William Wyler, 1953 (DVD: Paramount Home Video, 2006)

Acknowledgements

A grant from the The University of New South Wales faculty of Art and Design, Sydney, helped facilitate my research. Staff at its Clement Semmler Library were always accommodating, as were those at the library of the Art Gallery of New South Wales. To institutions and individuals who granted copyright permission, and to those who waived fees, thank you. Reaktion Books, as always, has been most agreeable to work with: a special thanks to Michael Leaman and Susannah Jayes, Rebecca Ratnayake, Jess Chandler and Camilla Gersh. Family are unfailingly mentioned in 'acknowledgements' and I do so here with pleasure: my brother Ivan and his wife Barbara and their children Laurian and Raphael; and my late mother, Bessie, and father, Leon. Finally, I must thank Dr Sheila Christofides, good friend and exemplary editor, who has gone well beyond the call of duty, and to whom I dedicate this book.

Photo Acknowledgements

The author and the publishers wish to express their thanks to the below sources of illustrative material and/or permission to reproduce it.

Alamy: 33 (Universal Images Group North America LLC); Dana Beveridge: 32; Courtesy of Pat Brassington and Stills Gallery, Sydney-EndFragment: 8, 9, 10, 11, 15; Getty Images: 16 (Siphiwe Sibeko – Pool), 31 (AFP); iStockphoto: 29 (Alatom); Picture Media: 12 (© GASP/MAXPPP), 13 (© Look Press Agency), 14 (© Michael Wright/WENN); The Metropolitan Museum, New York: 2; REX Shutterstock: 43 (Tom Nicholson).

Index

Illustration numbers are indicated by *italics*